Art on the ROCKS

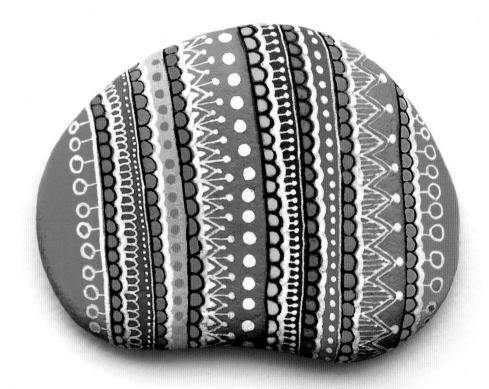

MORE THAN 35
colorful & contemporary rock-painting
projects, tips, and techniques
to inspire your creativity

F. Sehnaz Bac, Marisa Redondo, and Margaret Vance

Walter Foster

Brimming with creative inspiration, how-to projects, and useful information to enrich your everyday life, Quarto Knows is a favorite destination for those pursuing their interests and passions. Visit our site and dig deeper with our books into your area of interest: Quarto Creates, Quarto Cooks, Quarto Homes, Quarto Lives, Quarto Drives, Quarto Explores, Quarto Gifts, or Quarto Kids.

Inspiring | Educating | Creating | Entertaining

First published in 2017 by Walter Foster Publishing, an imprint of The Quarto Group, 6 Orchard Road, Suite 100, Lake Forest, CA 92630, USA.
T (949) 380-7510 **F** (949) 380-7575 **www.QuartoKnows.com**

ISBN: 978-1-63322-216-8

Project Editing: Dana Bottenfield
Page Layout: Krista Joy Johnson

Printed in China
5 7 9 10 8 6

Art on the ROCKS

• • • • •

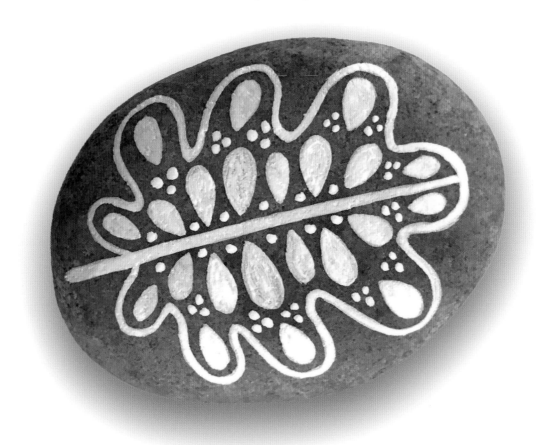

Table of CONTENTS

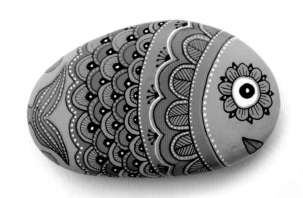

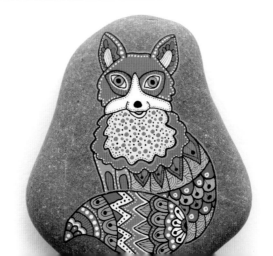

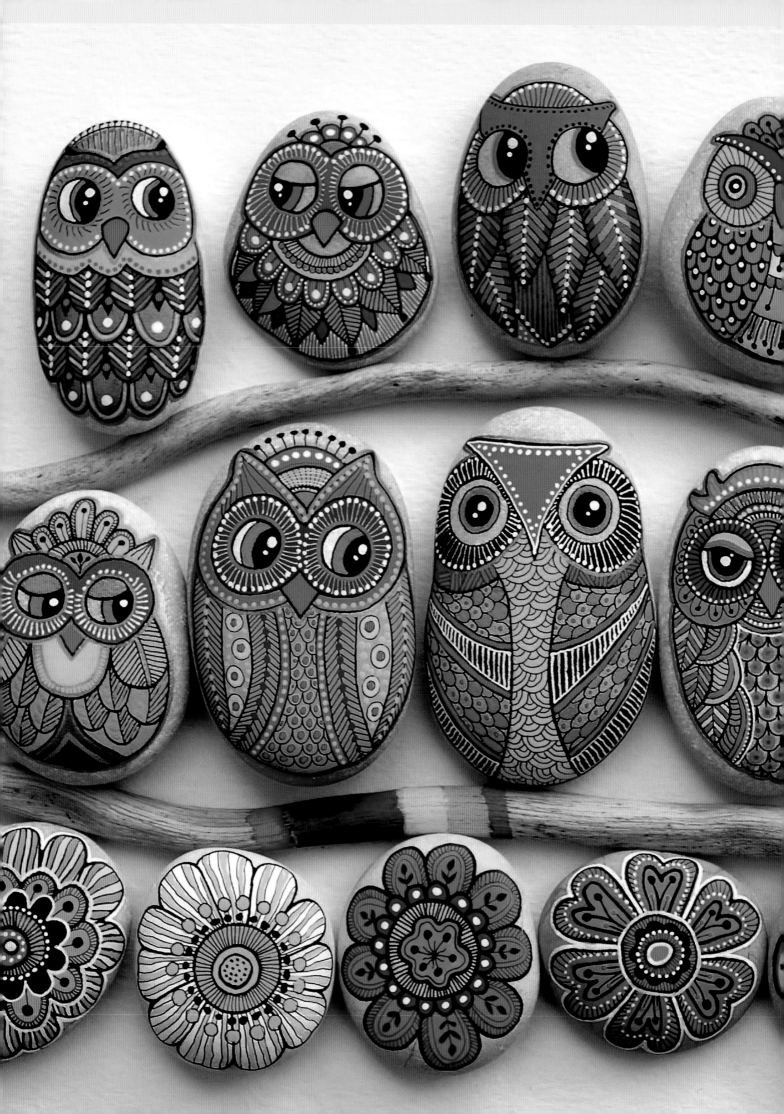

Getting Started

Tools & MATERIALS

with F. SEHNAZ BAC

Before you begin painting your stones, you need to have the correct materials and tools. Most of these items can be found at your local art and craft store. In time, as you paint more stones, you can decide which materials work best for you.

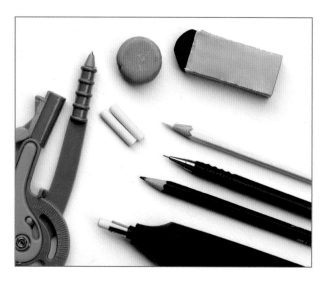

PENCILS & ERASERS

First you need pencils to sketch your designs onto the stones. I use hard lead pencils (at least 2H). To correct any errors on your sketch, use soft art erasers. You can use a compass for basic circles in mandala designs.

TRANSFER PAPER

There are different levels of transfer paper for light surfaced stones and dark surfaced stones. Use them with caution, as it can be difficult to remove transfer lines with an eraser.

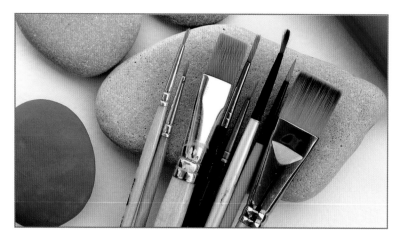

PAINTBRUSHES & SPONGES

You will need synthetic round brushes with different sizes to begin. I use tiny ones: sizes 0, 00, 000 for details, and sizes 14, 16 for larger areas. Always wash your brushes with soapy water after use. Use sponges to create bright backgrounds and special effects.

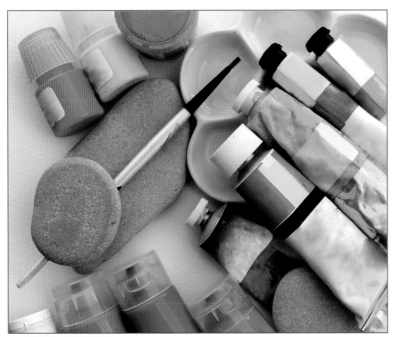

PAINTS

Acrylic paints are the best choice for stone painting. They are easy to apply, have brilliant colors, and cover the surface easily. You can find them in tubes, jars, or plastic containers. These paints dry very quickly, so keep their containers closed when they aren't in use. Alternatively, you can use water-based craft colors.

INKS & DIP PENS

You can use ink on your stone paintings. I use mostly acrylic inks, as they are highly pigmented and have intense colors. Inks are very good for fine details if you use them with a small brush or dip pen. Dip pens are also known as calligraphic pens, and come with a pen holder and different sized tips. You can use dip pens when you draw detailed line work on your painting.

VARNISHES

I use mostly acrylic varnishes to protect my painted stones. You can use glossy or matte varnish according your taste.

PAINT PENS, MARKERS, AND FINE-LINER PENS

When you want to draw or paint more detailed designs, you can use paint pens. There are many different kinds to choose from. I use water-based paint pens and markers.

Fine-liner pens are useful when you want to detail designs on your stones or pebbles. They have archival indelible ink, and extra-thin sizes are useful to work with tiny details. When you use them over painted areas, make sure your acrylic painted layer is completely dry so that they will not mix with acrylic colors.

Selecting & PREPPING ROCKS

with F. SEHNAZ BAC

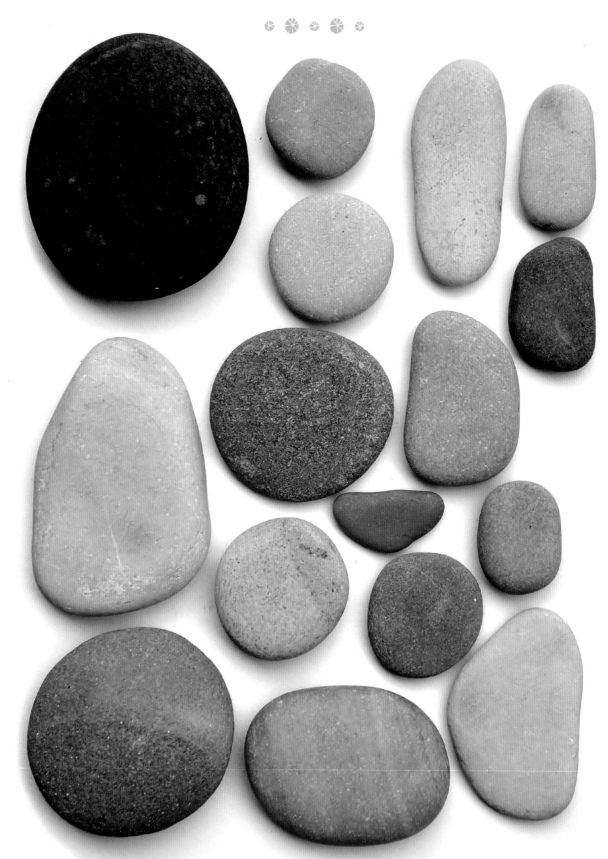

I collect stones on the beaches of the Adriatic Sea in Italy. There, I find many varieties of stones and pebbles. Some of them are very smooth with regular forms and flat surfaces, but some of them are rough and textured. If you aren't near a beach, river, or lake, there are other ways to find stones. You can buy your stones from craft stores, garden centers, or even online.

SELECTING & PREPPING ROCKS

When you want to paint rocks as a hobby or for your craft projects, first you need to search for the right rocks. The most common place to find nice stones is at the seaside. Along the shores of beaches, you can find stones of different sizes, shapes, and forms. Rivers, riverbeds, or lakes are also wonderful places to collect stones. When you collect your stones, it is important to choose the right sizes, shapes, and textures for the designs you want to create. You can collect as many stones as you like, and decide later what to paint on them, or you can choose specific stones for specific designs.

A variety of rocks, including natural rocks, can be purchased from rock suppliers. In these expansive yards, rocks are sorted according to size and type. You can also find flat flagstone in a variety of colors, thicknesses, and textures. Locate a rock supplier by searching your local area for "Landscape Supplies."

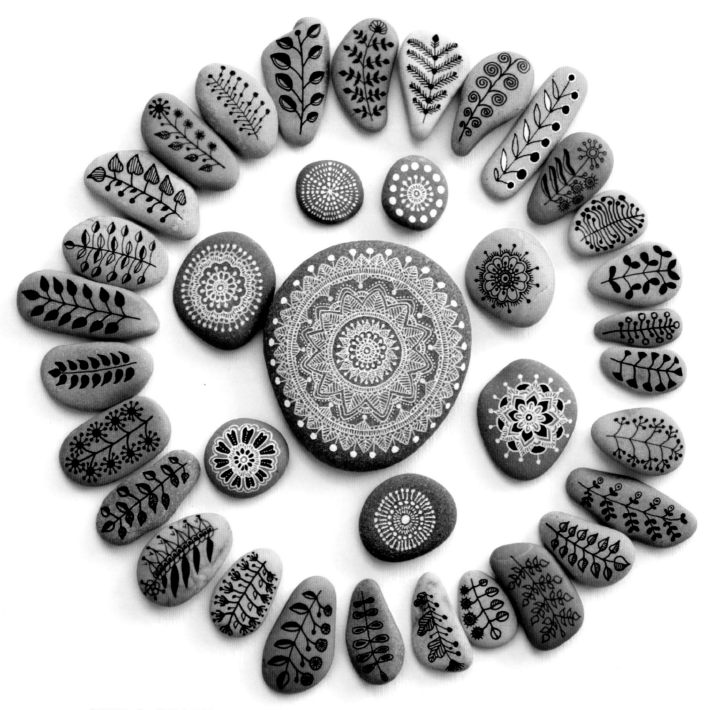

SIZE & SHAPE

Smooth and flat stones are ideal for working with ink or markers. You can paint or draw directly onto their natural surfaces. Rough and textured stones also work well if they have the desired shape you're seeking. I often choose my stones by their shapes: oval stones for owl or fish designs, round for mandalas, irregular shapes for bird or animal designs. Unique stones help increase my creativity by thinking of new ideas and concepts.

Stones have different colors that can create special effects when you paint them. For example, naturally dark or black stones are great choices for monochrome designs using white, gold, or silver ink. White, smooth stones are ideal for painting bright colors. Even rough stones with a special shape can look great after applying a few levels of paint to them.

WASHING & VARNISHING

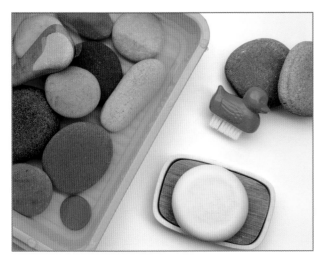

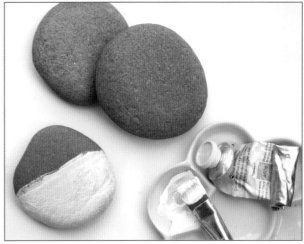

After I collect my stones, I leave them in a bowl of water for a few hours to soak off any excess dirt or sand particles. Next I clean them with a soft brush and mild soap. After rinsing with running tap water, I leave the stones to dry for at least one day out in the sun or in a warm place inside, near a window.

After they are completely dry, your stones are ready to paint! If your rocks are rough or porous, you can make them more smooth by adding a few coats of paint. Apply one or two coats of white acrylic paint, and once the paint dries, rub the surface with very fine sandpaper. This will help smooth the surface for your design.

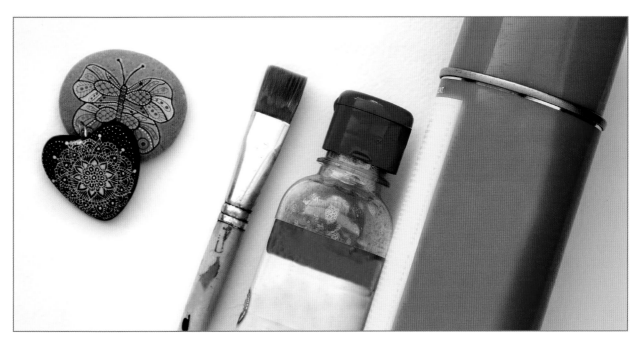

When you are finished painting your rock art, you will want to protect your work from sunshine, dust, or humidity. I always use a high-quality acrylic varnish (or varnish with UV protection). Varnishes can easily be found in craft stores or art shops.

Once your painted stone is completely dry, apply two or three layers of liquid varnish with a wide brush. If you are using a spray varnish, spray outdoors or in a well-ventilated area, wearing a mask. These kinds of sprays are highly flammable. After you have applied varnish, wait at least 48 hours to use your stones.

Techniques, Methods & TIPS

with F. SEHNAZ BAC and DIANA FISHER

Before you begin a project, it's a good idea to practice a few basic brush-strokes and painting techniques. This will help you get a "feel" for your paints so that you can paint with confidence. Don't be afraid to experiment and try a variety of painting techniques. If you make a mistake and want to start over, it's no problem; remember that acrylic colors can be washed off while they're still wet or painted over after they are dry.

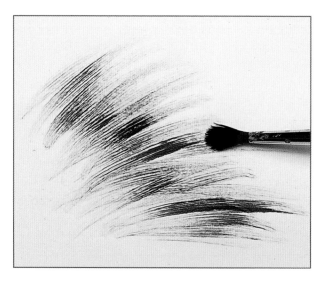

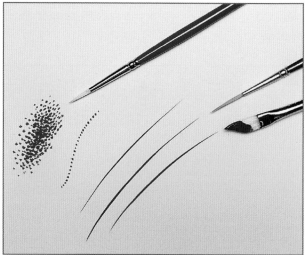

DRYBRUSHING

Drybrushing is an easy way to create the look of grass, fur, or anything that requires soft texture. It can also be used to build up color or to add subtle shading. First load a round brush with paint. Lay the bristles on paper and wiggle them back and forth while holding the handle vertically and pulling away slightly, the object is to wick away the wetness and to splay the bristles. Apply the paint using light, feathered strokes with the bristles splayed. When the paint dries, repeat as needed to build color or texture.

STIPPLING AND LINING

Stippling and lining are both important techniques. Stippling adds color and texture while letting the underpainting show through. To stipple, dot on paint with the tip of a round brush. For lining, use a liner brush to make clean, thin strokes; its long bristles can hold ample paint. Angled brushes also work well for lining, especially on round surfaces. Hold the angled brush so that the chiseled edge slides lightly along the surface. Practice using long, light strokes, pulling the brush gently away from the line as you go.

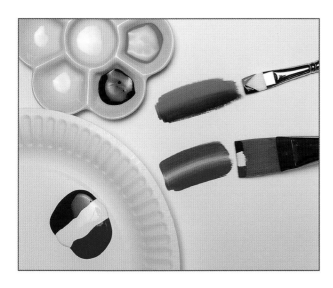

DOUBLE- AND TRIPLE-LOADING

Double- and triple-loading your brushes will produce a variety of color blends. To double-load a brush, dip each side in a different color as shown above, or squeeze two colors side by side onto your palette, and dip your brush in both at once. To triple-load, simply add a third color. In the example above, I've inserted white between green and red to create a gradation effect (the appearance of one color fading into another).

WET LAYERING

To highlight an edge, start with an application of your base color and let it dry. Then dip a round brush in clean water and wet the area just below the edge to be highlighted. Choose a color lighter than the base, and highlight the dry edge, stroking it into the wet area. Dry your brush on a towel, and then use it to absorb any excess moisture. You can use this same method to shade an edge, but use a color that is darker than the base.

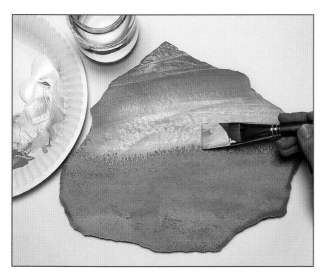

PAINTING ON A STONE SLAB

A large, flat stone slab or piece of flagstone can be used for a unique canvas that can be displayed on an easel. The layered edges of the flagstone can be left unpainted for added effect. Wash the flagstone well to remove any loose layers that could easily chip off during painting.

USING WOOD FILLER

When an otherwise perfect rock is marred by a hole or a crack, wood filler can correct the imperfection. Start with a clean rock. Fill in the hole with a putty knife, and then remove the excess. If desired, sand the filler after 15 minutes. Let the wood filler dry for 2 hours before painting.

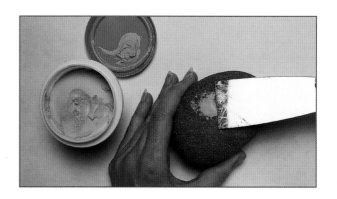

PAINTING OR DRAWING ON A BARE STONE

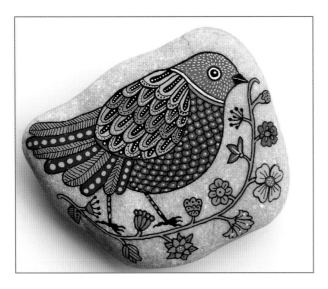

If you want your painted stone or pebble to be a piece of wearable art, add some small metal rings to use them as pendants or bracelets. You can use a drilling tool and a pair of pliers. Once you drill a tiny vertical hole into your stone, insert the metal ring and fix into place with hot glue. When drilling, be sure to always wear goggles and a mask to protect yourself from flying debris.

This method is perfect for when you have flat, smooth-surfaced stones. Just sketch your design on stone and fill it in with your chosen colors.

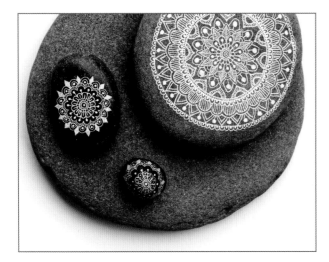

Create monochromatic designs directly onto the stone's surface with liner pens or dip pens.

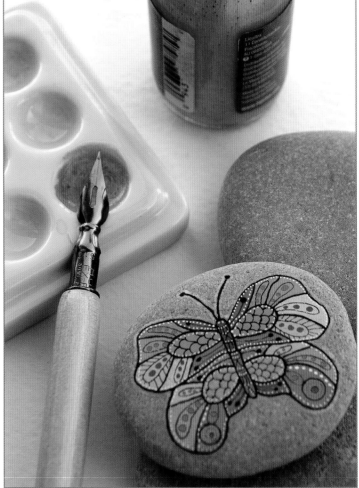

Adding contours to your design allows shapes and colors to really stand out.

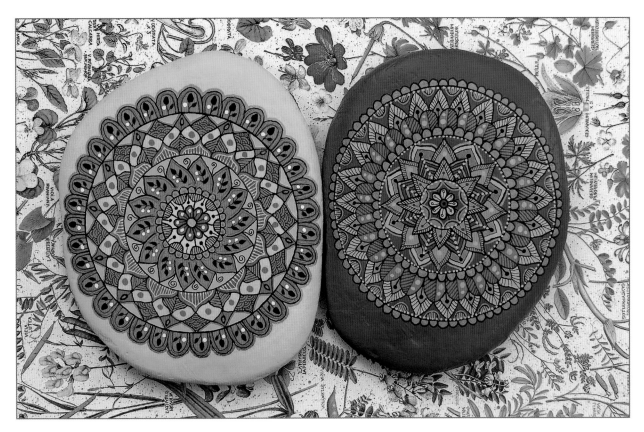

PAINTING OR DRAWING ON A PAINTED STONE

Use this method if the surface of your stone is covered with acrylic paint or ink. Once the painted surface is completely dry, add your design with pencil, fill with color, or add details.

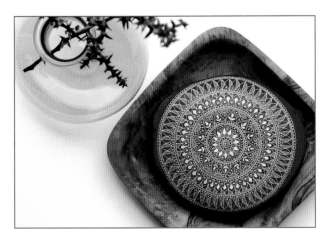

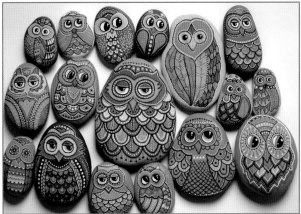

Painted stones are perfect for monochromatic designs. To create a monochrome design on your stone's surface, both natural or painted, work with dip pens, tiny brushes, and acrylic inks. After you sketch your design on the stone, draw over the sketch with ink or a fine-liner pen to cover all sketch lines. When you are finished creating your design, add contour lines with dip pens and acrylic ink.

When you start to paint your design, use brushes, acrylic paint, paint pens, acrylic inks, or tiny brushes. Try to cover all areas, and stay inside sketch lines. Let the paint dry for one hour. Then, if the colors are not as bright as you wish, you can pass a second layer over them. When this layer dries, use fine-liner pens to draw outlines.

SPONGING ON BACKGROUND COLOR

Sponge on beautifully blended backgrounds for your favorite Zen inspirations.

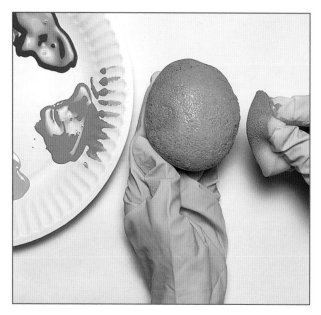

Step 1 Dip the sponge in your lightest color, and dab the paint onto the exposed half of the rock until it's covered. Immediately sponge your medium color into the wet paint, leaving a portion of the top area untouched. Sponge your darkest color into the wet edge of your medium color and down as far as you can go. After the paint dries, turn the rock over and continue sponging the darkest color onto the bottom of the rock.

Step 2 Set the rock on the dry side, and let the paint dry overnight. Then transfer the chosen symbols to the center of the top of the rock. (See "Transferring a Design" below.)

TRANSFERRING A DESIGN

To transfer a design onto a rock, first reduce or enlarge the design on a copy machine to fit your rock. Color the back of the design with white pencil for dark rocks and black pencil for light rocks, so the paper acts like carbon paper. (You can use carbon paper also, but it smudges more easily.) Cut out the design and tape it down with low-tack artist's tape. To place a pattern over a very round rock, cut out triangles from the edges, so the paper will conform more easily. Transfer the image by tracing over the lines with a ballpoint pen, using light to medium pressure.

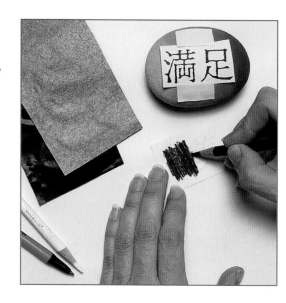

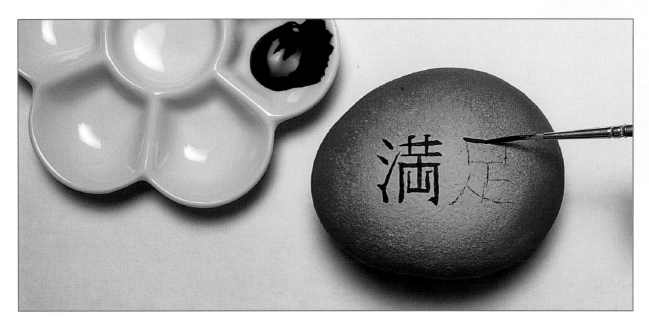

Step 3 Next paint the symbols using a liner brush. I used black paint, but you needn't restrict yourself—be creative and explore different color combinations. Try to always stroke toward the thin end of a line, lifting the brush up and away as you finish. If your strokes are skipping over the rock, dilute the paint more—being careful not to thin it too much or the paint will be runny and transparent—and stroke more slowly.

Step 4 When you're done painting, examine the rock to see if you can find any small mistakes. It's always easier to touch up errors when the paint is dry. Once you're satisfied with your results, seal the rock with clear matte acrylic spray.

ROCK LETTERING BY HAND

A rock paperweight that you have hand-lettered with your favorite inspirational saying makes a thoughtful gift or a useful affirmation for yourself. To master lettering techniques on a rounded three-dimensional surface, you'll want to choose smooth, flat rocks with no pits or ridges.

Permanent Marker When lettering on a bare rock, I recommend using an extra-fine permanent marker for better control. Use a light touch and keep the maker moving; the ink may bleed if you press in one place for too long.

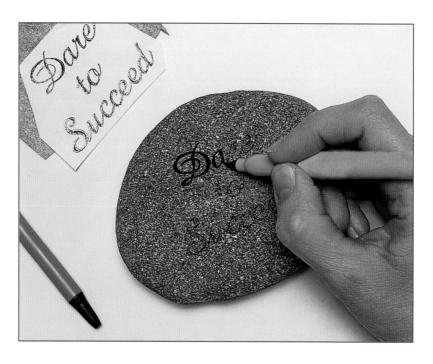

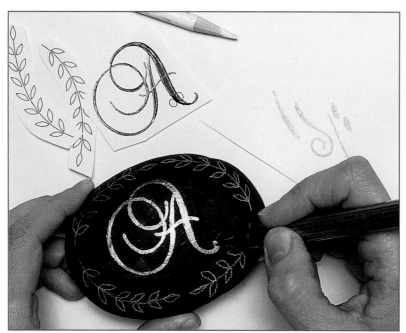

Paint Marker To letter on a painted rock with paint markers, first apply your base color with a wide flat brush. Once dry, transfer your design with a white pencil. Then use a metallic paint marker to paint the center initial and the surrounding leaf sprays; keep the marker moving and use a light touch for best results. When the metallic color is dry, touch up any mistakes with your background color.

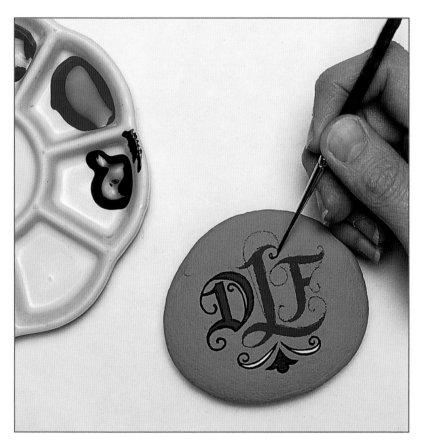

Paintbrush Transfer your design onto the rock with colored pencil (it is least likely to smudge on the paint). Then use a liner brush to fill in the wide portions of the letters and the flourish with color. Outline the design with black, keeping the brush tip tapered and clear of buildup. Create the swirls in parts, always pulling the brush toward you. I prefer to outline a curve from the inside while pivoting my hand. Once you've finished working on these functional and attractive paperweights, be sure to seal them carefully before displaying them or giving them away. You can also finish the backs with small self-adhesive felt pieces, available at art and craft supply stores.

CLEAR-COATING THE FINISHED PIECE

A glossy clear coat will enliven and enhance color enormously. Enrich and protect your rock creations at the same time with a permanent, waterproof, clear acrylic spray finish. A light coating is all that is needed. For serious water- and weatherproofing, spray several light coats. (Consult the specific directions for the brand you choose.)

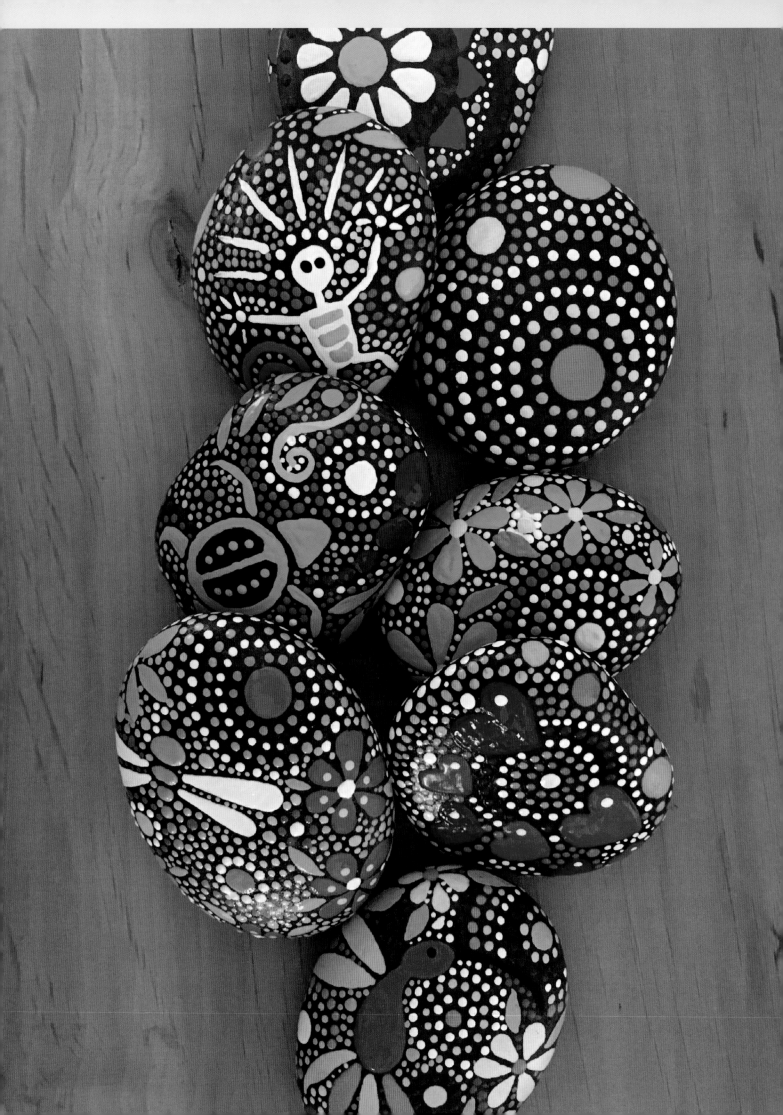

Mandalas

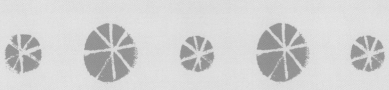

Sunset

with MARGARET VANCE

Mandala dot rock painting is a meditative practice. The size and irregular shape of this natural canvas, along with the need to focus on the size, color, and placement of each dot of paint causes the mind and body to slow down and focus on the small world you are creating.

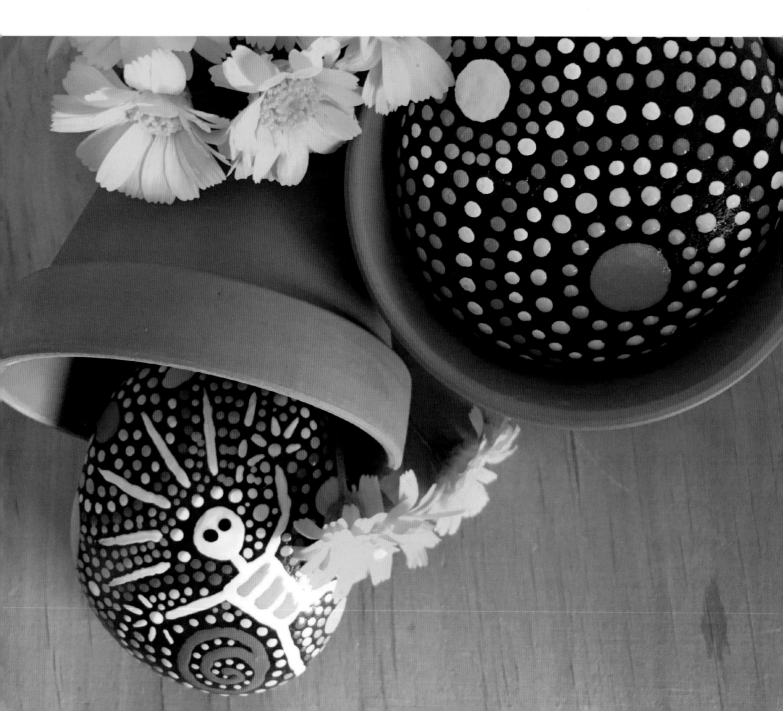

Step 1 Choose a flat, smooth rock with a shape you like. The rock's shape, size, and texture will determine your mandala design. Wash the rock well to remove any dirt from the surface and let it dry completely.

Step 2 Choose a color scheme and inspirational concept (field of desert flowers, wedding bouquet, sunset sky, or hummingbird's breast) before you begin. Because the canvas is so small, choosing three or four colors, with white and black as balancing colors, keeps the design focused.

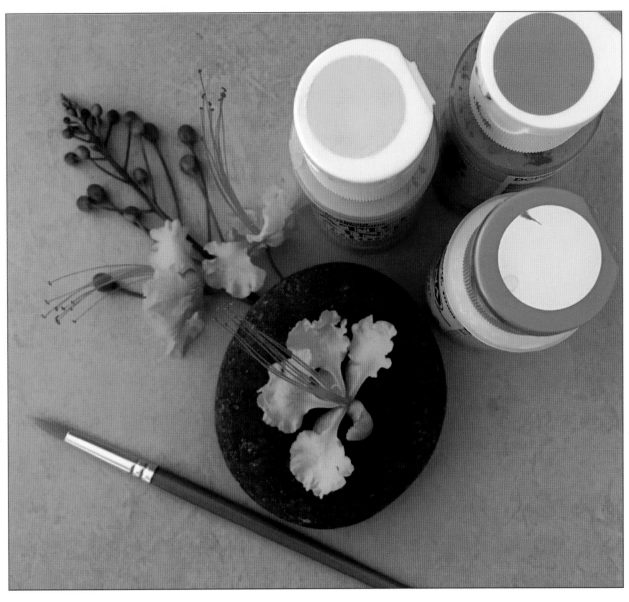

Step 3 Let the rock tell you where to begin and how to proceed. Unlike a traditional square or rectangular canvas, rocks are rarely a perfect circle or shape, and the surface may have slight dips and grooves in it. Use those imperfections to inspire your design. The rock's shape and surface can help you determine the size of your first circle and guide your other ring colors and sizes.

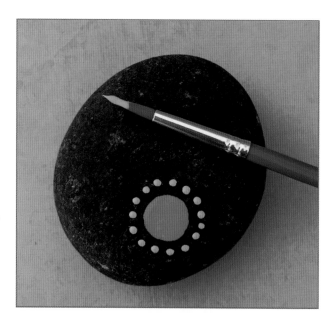

Step 4 When choosing to use a dot pattern to create your mandala, take your time with each dot. To create a uniform-like pattern, the dots of each ring should be a similar size and distance from the previous ring.

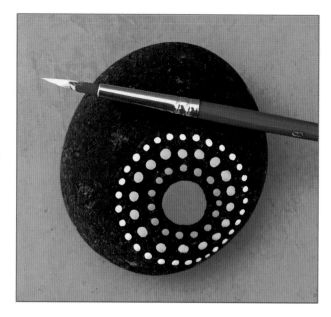

Step 5 Varying the size and colors of the dot rings you create, will provide texture and unique design elements to your mandala. Don't over-think this process. Let the rock and your own instincts guide you. Let sections of the paint dry completely before handling the rock to access other sections. Most acrylic paint takes 10 minutes to dry.

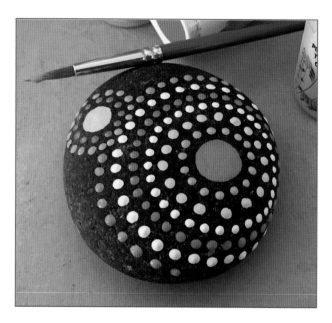

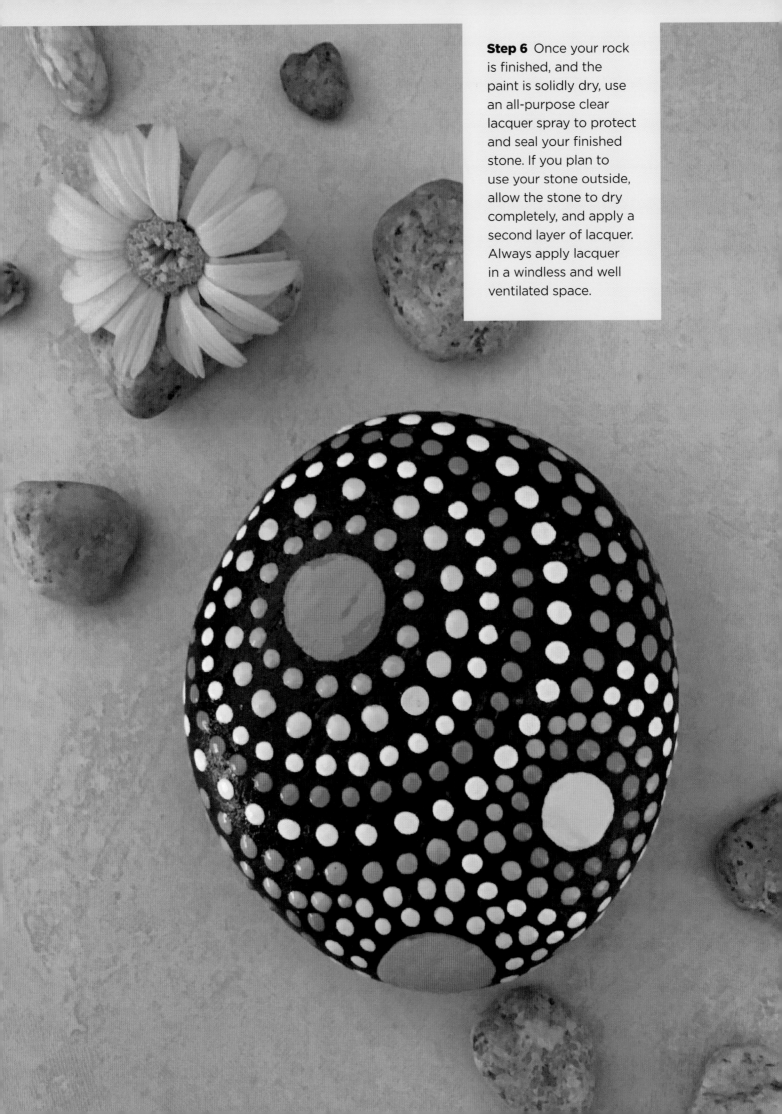

Step 6 Once your rock is finished, and the paint is solidly dry, use an all-purpose clear lacquer spray to protect and seal your finished stone. If you plan to use your stone outside, allow the stone to dry completely, and apply a second layer of lacquer. Always apply lacquer in a windless and well ventilated space.

Nature

with MARGARET VANCE

Inspiration for your mandala rock art design can come from naturally occurring circles in nature like flowers, a bird's eye, or pools of water. The celestial circles in our universe such as the sun, moon, and stars are also excellent sources of inspiration.

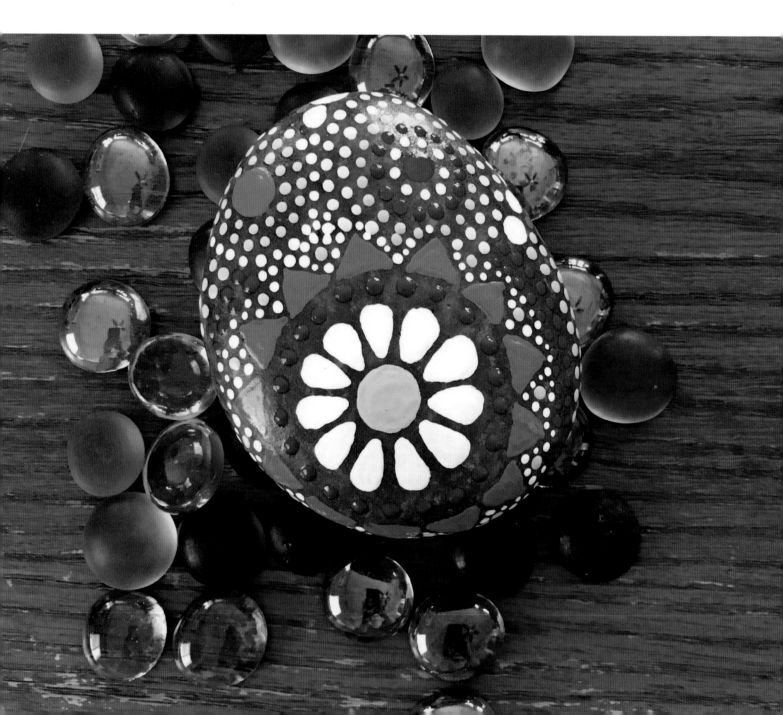

Step 1 Choose a flat, smooth rock with a shape you like. The rock's shape, size, texture, and color can guide your color and design choices. Remember that your rock should be free of dirt and completely dry.

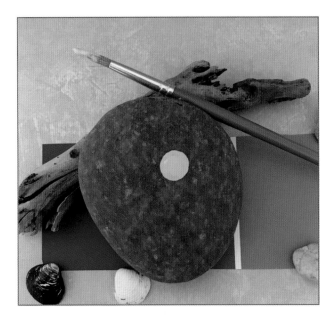

Step 2 Choose a color scheme and inspirational concept. Color swatches from paint stores or from online decorating sights are a great source of inspiration. Colors that are harmonious and drawn from natural settings can help inspire and guide your design. Remember that using white or black as highlights can keep the design focused. Start your main mandala slightly off center to give the design a more natural or organic feel.

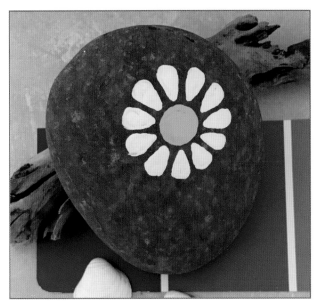

Step 3 Mandala designs can be as simple or as complex as your imagination allows. You can use flower petals, leaf shapes, triangles, dashes, or oval and circular designs alongside your Mandala dot rings. Adding other shapes and designs adds interest and drama to the design.

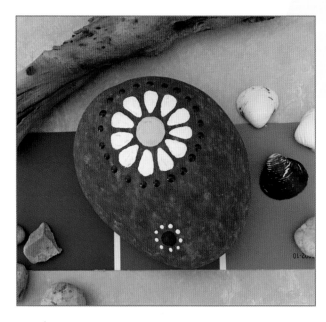

Step 4 When choosing to include a dot pattern to your mandala design, take your time with each dot. Each ring of dots should be a similar size and distance from the previous ring.

Step 5 Be very careful to let sections of the paint dry completely before handling the rock to access other sections. Most acrylic paint takes 10 minutes to dry.

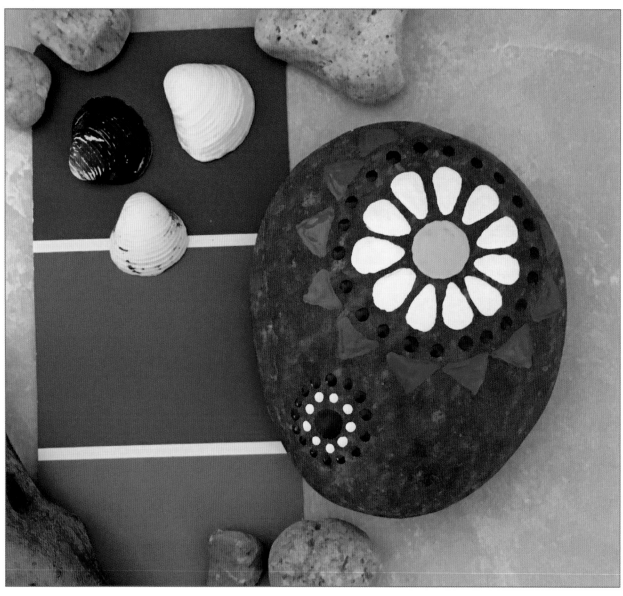

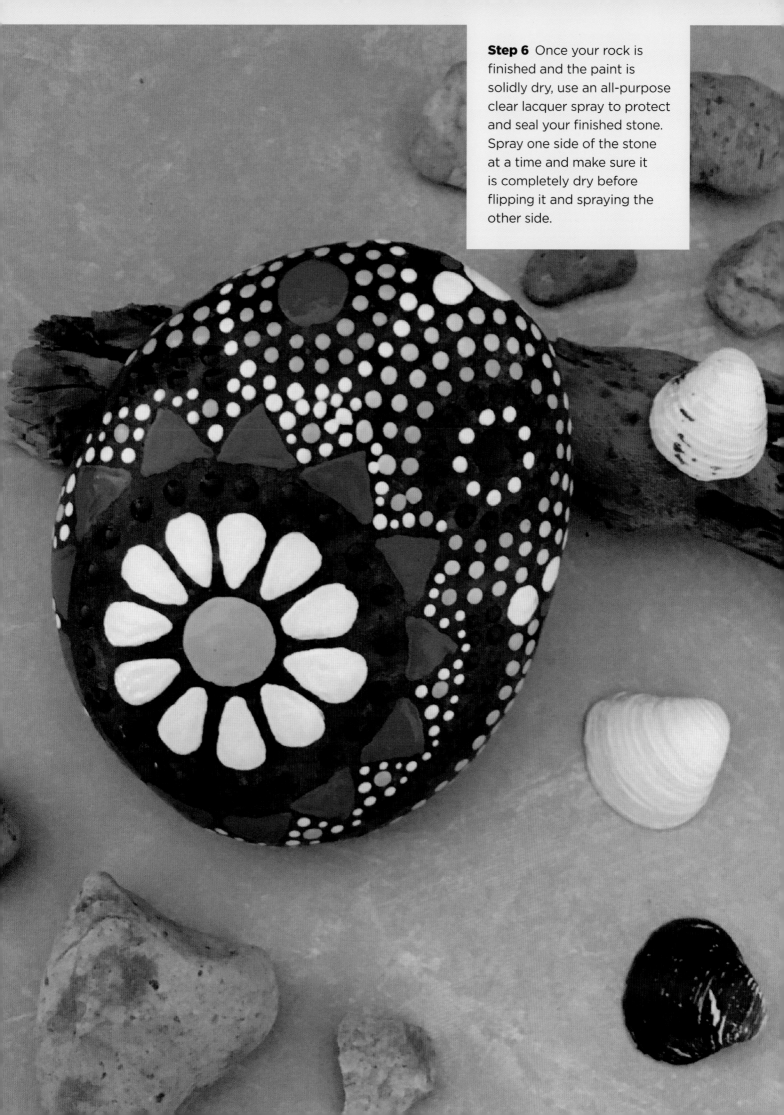

Step 6 Once your rock is finished and the paint is solidly dry, use an all-purpose clear lacquer spray to protect and seal your finished stone. Spray one side of the stone at a time and make sure it is completely dry before flipping it and spraying the other side.

Blue

with F. SEHNAZ BAC

Your mandala stone can be used as a paperweight, bookend, or as a decorative object in your home or garden. Try turning your stone into wall art by attaching it to a wood panel and framing it. You can also simply use your stone for personal meditation. The choice is up to you!

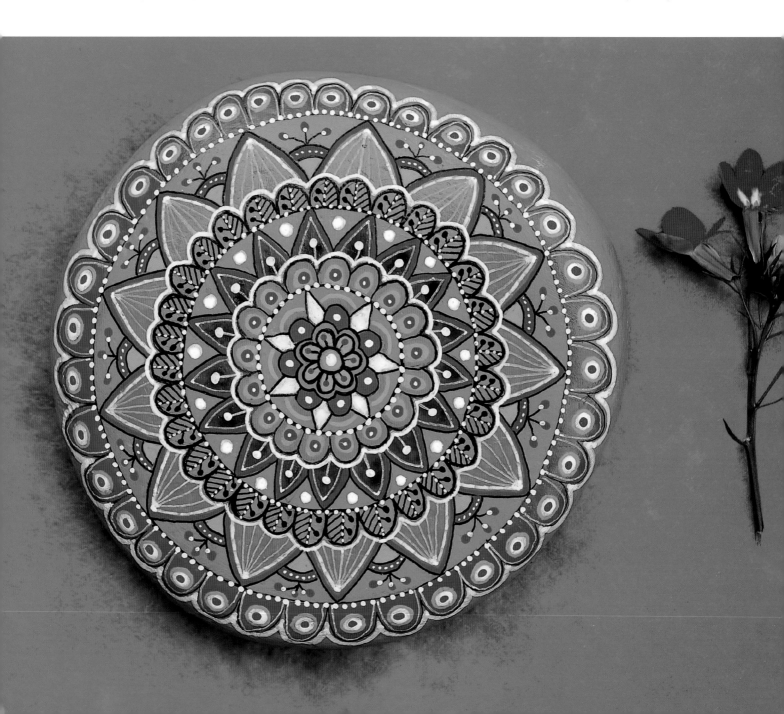

Step 1 Find a flat, round stone with a smooth surface. If you can't find a smooth stone, you can smooth your stone with extra layers of paint.

Step 2 Paint the surface of your stone with turquoise acrylic paint and a large brush. If your stone's surface is porous, fill in the porous parts with paint by applying soft pressure to your brush. Wait until the paint is completely dry to continue.

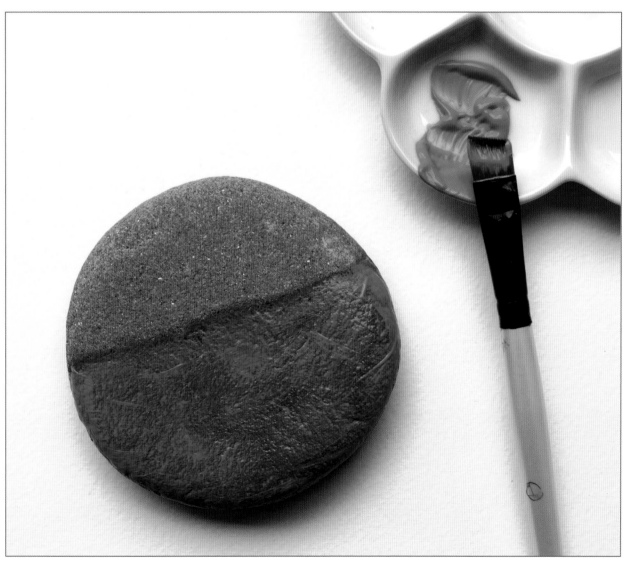

Step 3 Continue painting the stone until it has a smooth surface. Don't use excessive paint for each layer. Thin paint layers attach better and dry quicker. Always remember to wait until the paint is completely dried to start a new layer.

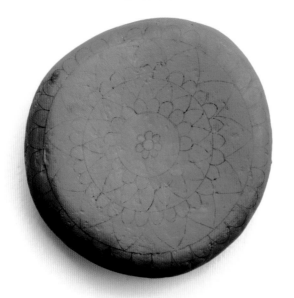

Step 4 When the paint is dry, sketch your design on the stone with a pencil. Use clean lines, and don't press too hard on the paint's delicate surface. Begin with a small circle in the center, then draw three concentric circles with spaces between them. Fill in your mandala design with rows of semi-ovals, triangles, and leaf-like patterns around the circles.

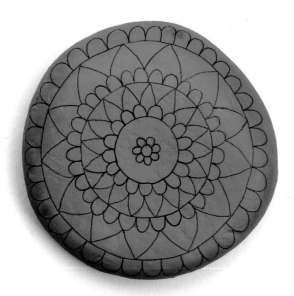

Step 5 Gently remove errors with a soft eraser. If your pencil lines are difficult to see, pass over them with a thin black liner pen.

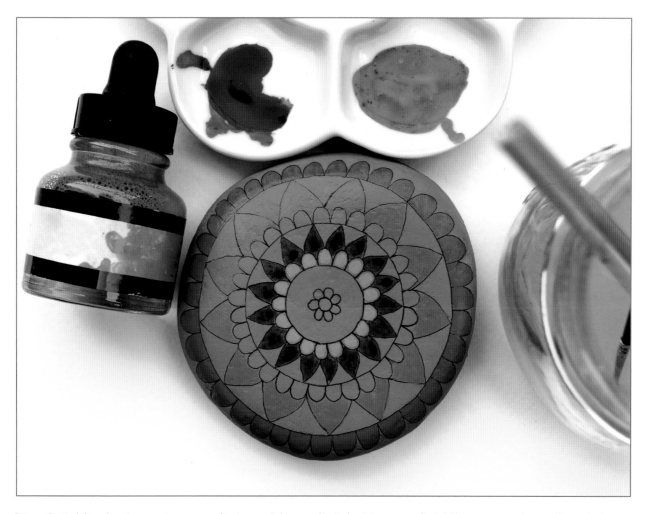

Step 6 Add color tones to your design with acrylic ink. It's more fluid than normal acrylic paint and moves your brush easily. With a very thin round brush, start to paint your mandala design. Use different hues: light blue, cobalt, and ultramarine. You can pass a second layer of inks if you want brighter colors.

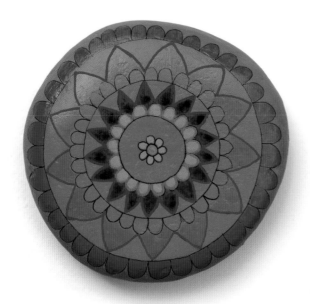

Step 7 Add some contour lines to the painted parts of your mandala design using paint pens. These lines will define the different hues of the color and add a stylish look to your mandala design.

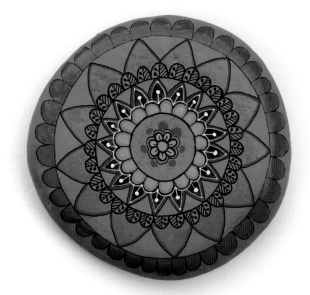

Step 8 Add triangle and leaf-like rows to the center part of your design. Pass black contour lines over your design. Fill some parts in with thin, parallel lines (black dots and lines). Pass another contour line around the rows with white ink and a thin dip pen. Use white dots and lines to fill triangles and other design elements.

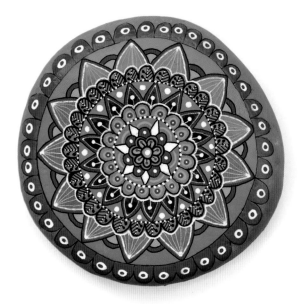

Step 9 Add more details to your mandala design in this phase. Draw white lines inside of big triangles. Use white and blue dots in different empty spaces of your design. Put small white dots over the main circle lines of your design. Add a white contour to the inside of each semi-oval on the outer design.

Step 10 To finish adding details to your mandala design, draw a bold white contour to the outside of semi-ovals as a border. Add plant-like motifs to empty spaces between the big triangles. Use acrylic varnish to seal and protect your painting.

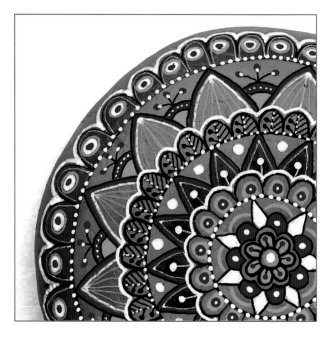

Set time and distractions aside before you begin to paint to assure an enjoyable process and a beautiful finished product.

Color

with F. SEHNAZ BAC

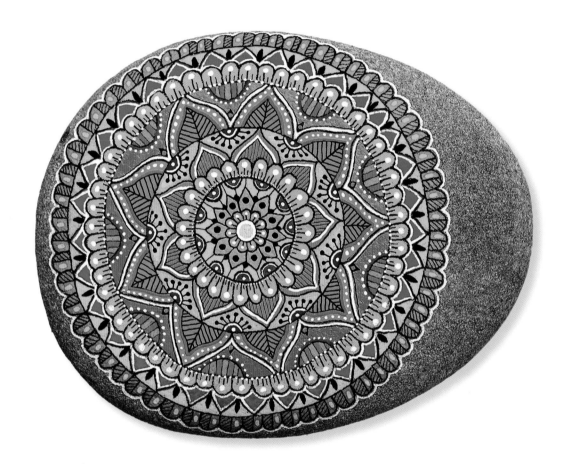

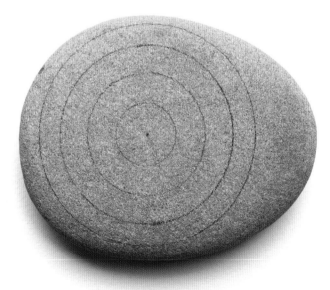

Step 1 Look for a round, flat stone with a smooth surface, so you can work directly on the stone's natural surface. Mark your center point on the stone to begin the sketch of your mandala. Use an H2 pencil, not too soft, which won't leave lead powder on the stone's natural surface. Then draw four concentric circles around your center point. Make sure to leave space between the circle lines. You can use a compass for the circles, or you can draw them freehand.

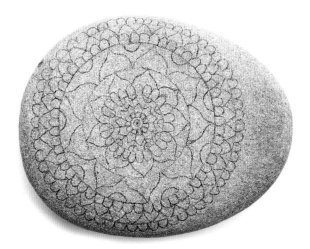

Step 2 Add all the details of your mandala design, drawing rows of half circles, leaf-like shapes, semi-ovals, and triangles around the circle lines.

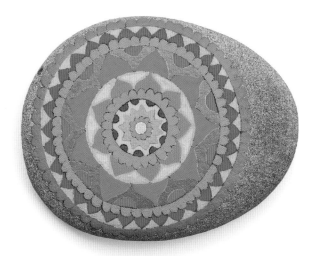

Step 3 Start to fill your design with paint. You can use acrylic paint and acrylic inks as well. Use very thin round brushes to work easily in the small spaces. Choose bright, bold colors to give contrast to your design.

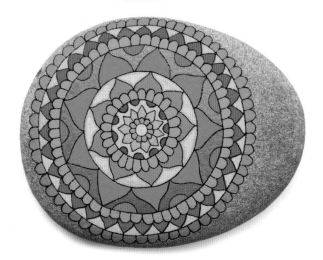

Step 4 Using an extra-fine tip black liner pen, draw contour lines throughout your design for a clean and defined look.

Step 5 Now you are ready to add the details to your stone. Start from the center so that pen lines will dry as you move on to the next details.

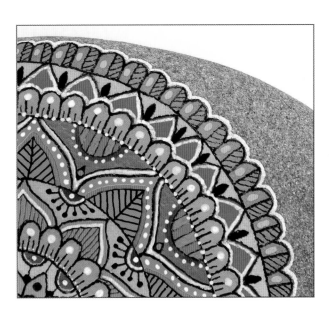

Design Detail

- Add white dots and black lines to row one and black dots to row 2.
- In row 3, draw some small black triangles between big triangles.
- In row 4, draw semicircles over the black triangles, and draw a white contour inside them; then add white dots.
- Draw thin lines inside the semiovals on row 5, and then add dots to the longer lines.
- Make smaller triangles inside the leaf-like triangles in row 6, and pass a white contour over them. Draw thin, vertical parallel lines inside the smaller triangles.
- To fill the space between the leaf-like triangles, add some lines with dots to the semicircle motifs in row 8. Also add white contour lines and white dots inside the semicircles.
- Draw smaller triangles inside the big triangles in row 10. Use white dots in the spaces between the two triangles. Divide into smaller triangles with a thin vertical line, and fill each part with diagonal, parallel lines.
- Pass a contour through the smaller triangle with a colored paint pen, and a white contour around the bigger triangle. Add another black triangle between the big triangles, and add dots around them.
- Add parallel vertical lines to the semicircles in row 12, and paint over some of these empty spaces with another color.
- Add a contour line to each semicircle in row 11 with a colored paint pen and put some white dots over it.
- Draw thin black lines inside the semiovals in row 13, and add white dots to the longer lines.
- Pass a white contour line inside the red triangles in row 14, and add small black leaf motifs between the triangles.
- In row 15, divide the semiovals in two with a thin vertical line, and draw diagonal parallel lines inside one half. Put a yellow dot in the other half.
- Finally, draw a white, bold contour line over the tops of the semiovals.

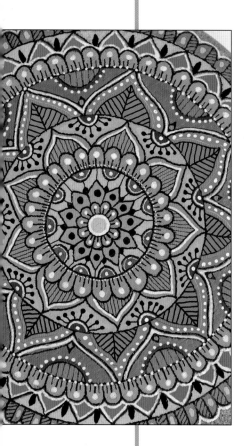

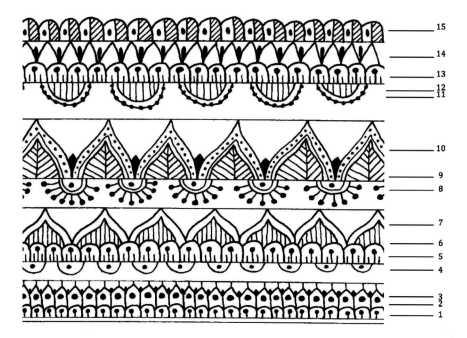

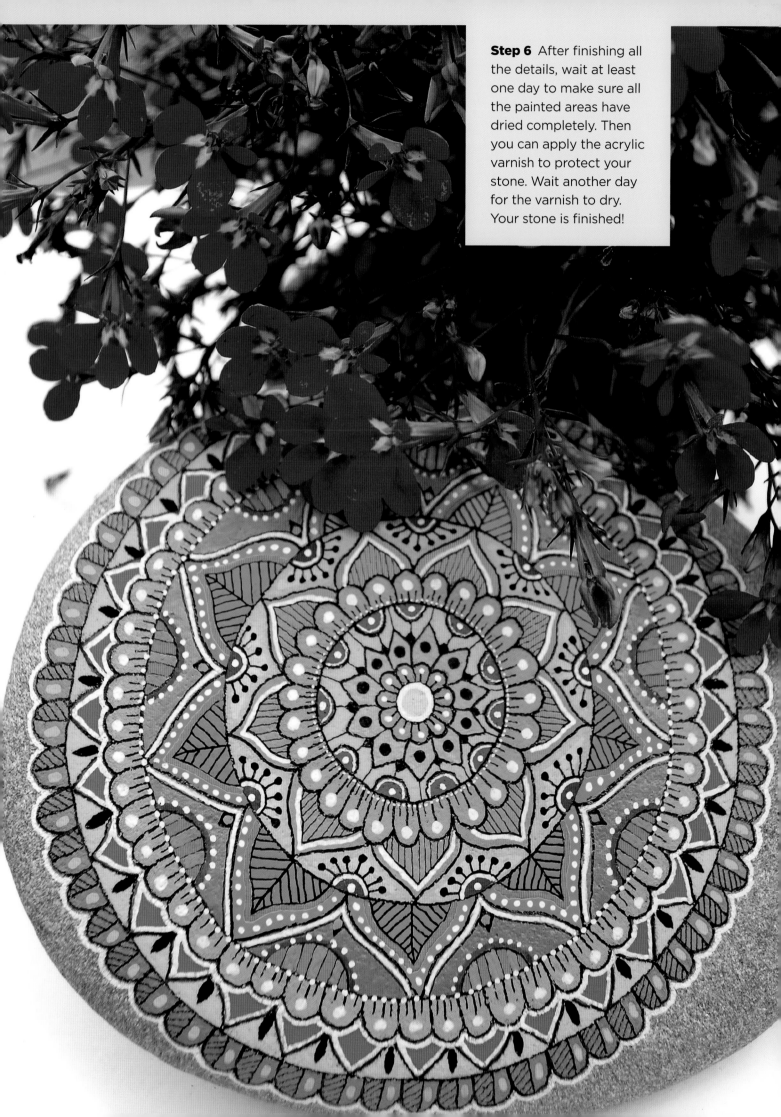

Step 6 After finishing all the details, wait at least one day to make sure all the painted areas have dried completely. Then you can apply the acrylic varnish to protect your stone. Wait another day for the varnish to dry. Your stone is finished!

Flower

with MARISA REDONDO

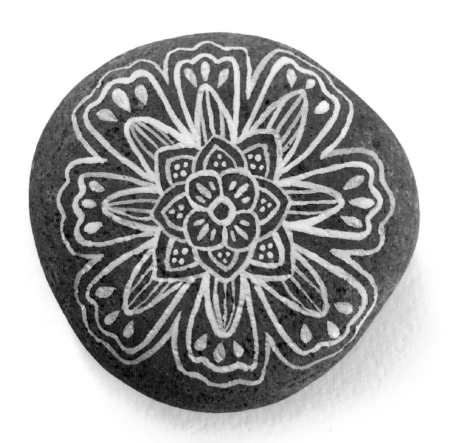

Step 1 Choose a round rock. Apply a thin and even layer of varnish to your rock with a Filbert paintbrush. Once the varnish is dry, begin by painting a small circle in the center of your rock. Add four small flower petal shapes around the circle.

Step 2 Add a little detail to the flower petal shapes, and then add another set of petals between each shape.

Step 3 Add a second set of flower petals, and then paint long U-shaped petals extending from the ends.

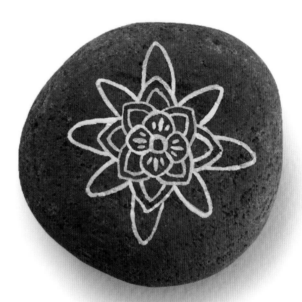

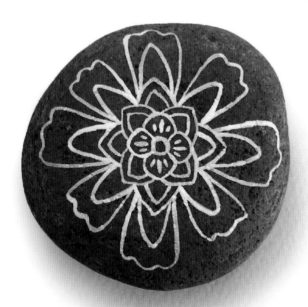

Step 4 Paint larger flower petals around each U-shape, adding a slight wave to the end of each petal.

Step 5 Fill the petals with decorative designs, dots, teardrops, lines, or any other shapes you prefer.

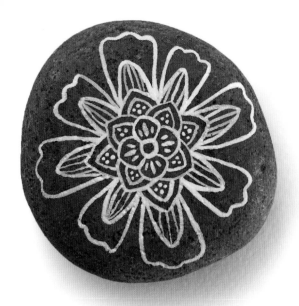

Step 6 Paint a simple outline that borders the entire flower.

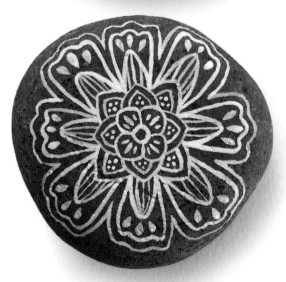

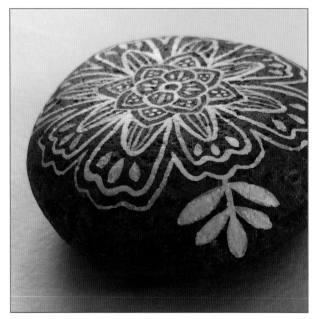

Step 7 At the end of each outer petal, paint a small leafy branch, each with five leaves.

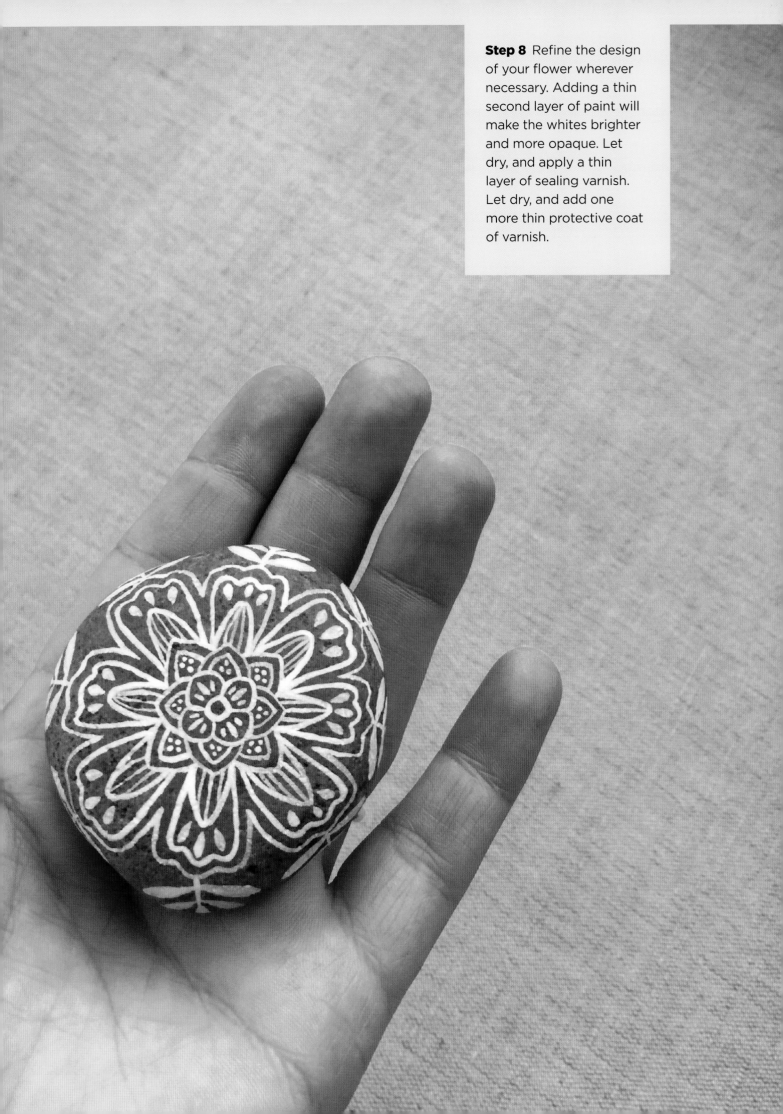

Step 8 Refine the design of your flower wherever necessary. Adding a thin second layer of paint will make the whites brighter and more opaque. Let dry, and apply a thin layer of sealing varnish. Let dry, and add one more thin protective coat of varnish.

Dandelion

with MARISA REDONDO

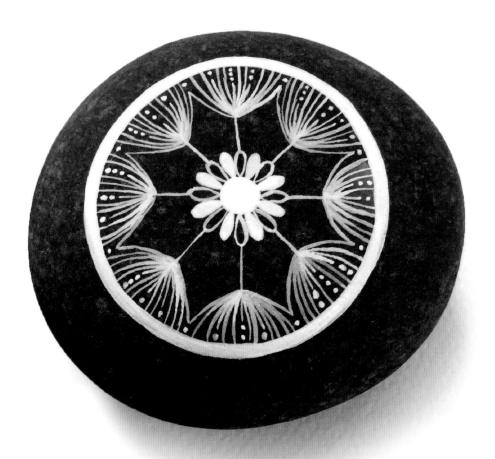

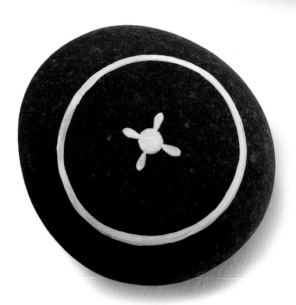

Step 1 Choose a round rock for this painting. Apply a thin and even layer of varnish to your rock with your Filbert paintbrush. Once the varnish is dry, use a pencil to draw a light circle outline on your rock. Paint over your circle outline with a size 1 round paintbrush. Paint a dot in the center of the circle.

If you're working on a round rock, you may be able to paint a more precise circle by slowly spinning the rock as you hold your paintbrush in place.

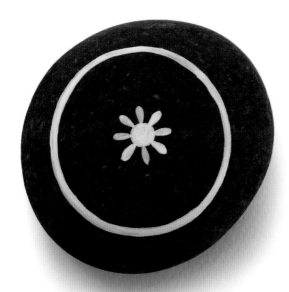

Step 2 Begin painting 16 small dandelion spores around the dot with a size 00 paintbrush.

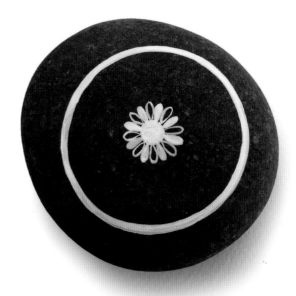

Step 3 Fill every other spore in with paint.

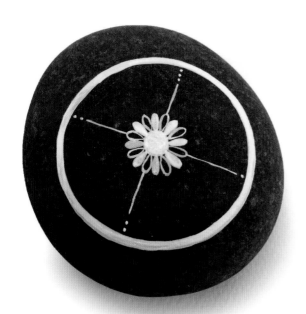

Step 4 Paint a straight, thin line from every other spore towards the outer circle, leaving a small space between the end of the line and the outer circle of the dandelion.

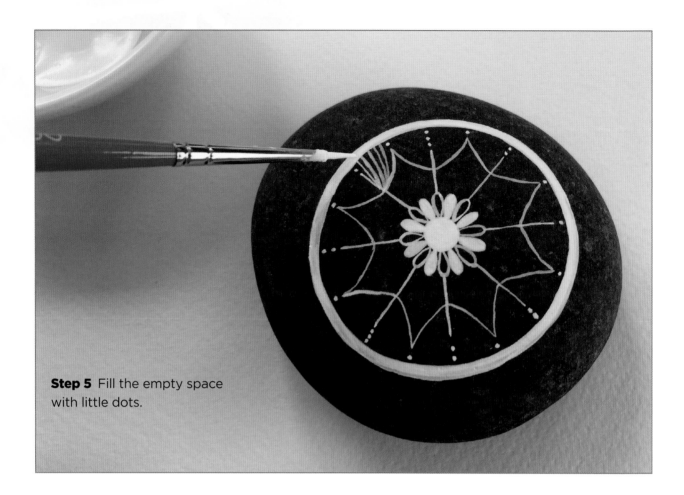

Step 5 Fill the empty space with little dots.

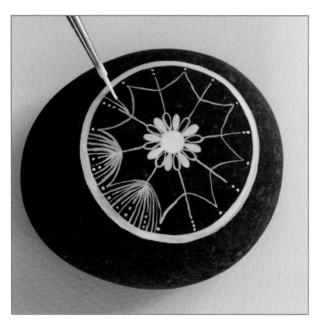

Step 6 Paint a single dot evenly between each line.

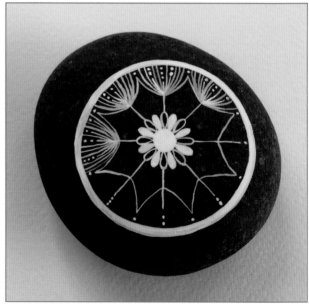

Step 7 At the middle of each line, paint a curved line branching up to the outer circle. Repeat this process for each dandelion spore. Add small dot details to enhance your painting.

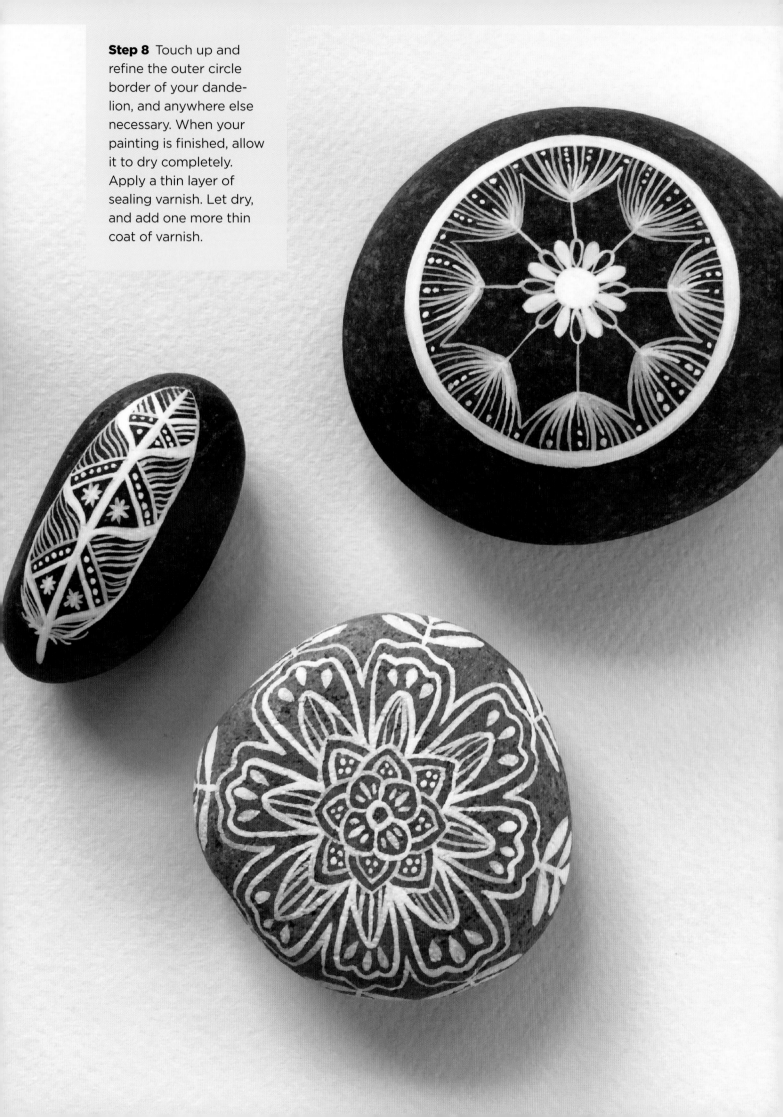

Step 8 Touch up and refine the outer circle border of your dandelion, and anywhere else necessary. When your painting is finished, allow it to dry completely. Apply a thin layer of sealing varnish. Let dry, and add one more thin coat of varnish.

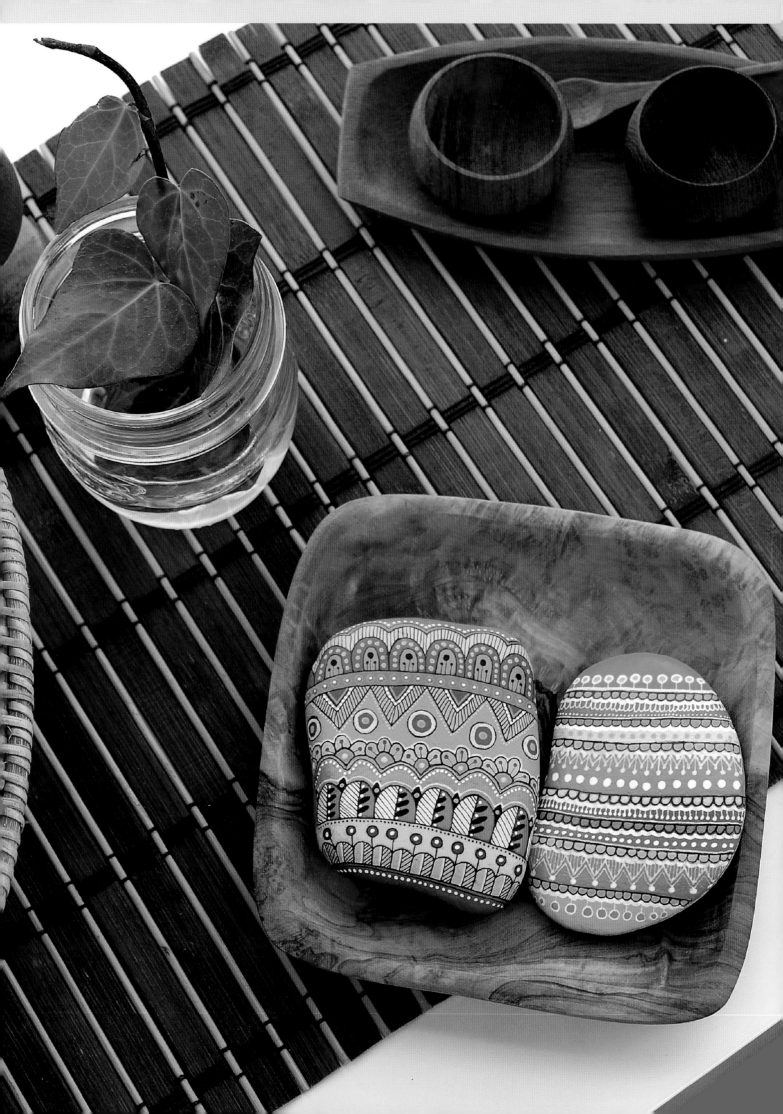

 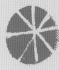 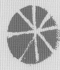

Patterns

Hearts

with MARGARET VANCE

Using patterns is a great way to decorate and adorn a rock. Using similar shapes and colors in a repeating manner can create beautiful art on any canvas. This method is particularly nice on natural stones.

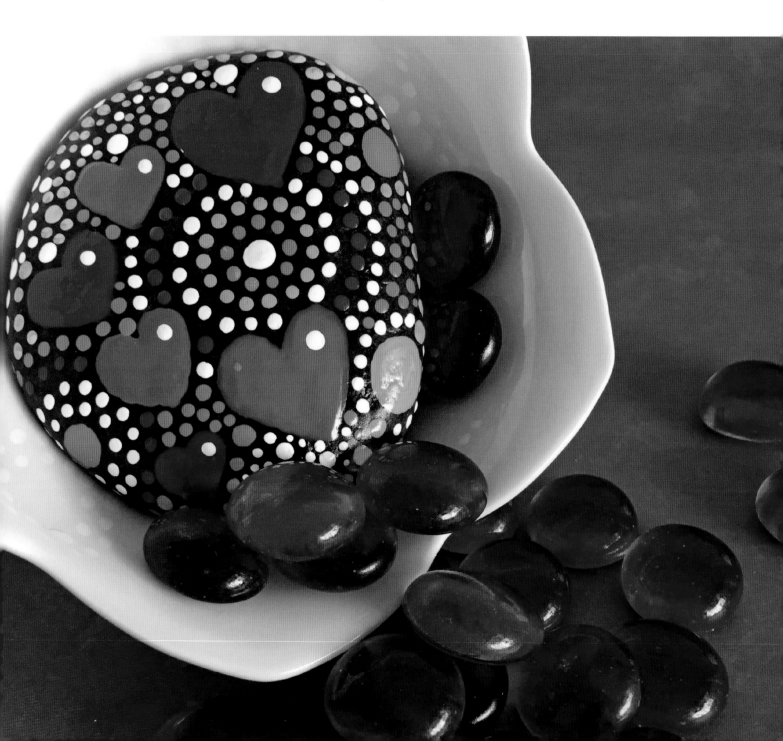

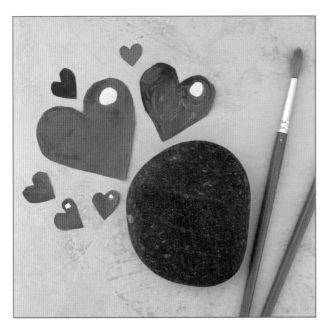

Step 1 Choose a flat, smooth rock with a pleasing shape. Wash the rock well to remove any dirt from the surface. Let it dry completely. Determine a color scheme. Keep in mind that pattern drawings repeat shapes, colors, and designs. This pattern uses a traditional red theme with heart patterns and mandala dot art.

Step 2 Find a starting point for your pattern. Let the rock's shape, size, texture, and color guide your design choices.

Step 3 Next, using the rock's shape and size as a guide, place a pattern of hearts on the rock. Use different shades of red to add interest to the pattern. A dot or square on one side of each heart can simulate a glint of light bouncing off the surface. Put this addition on the same side of every heart to emphasize the direction of the light source.

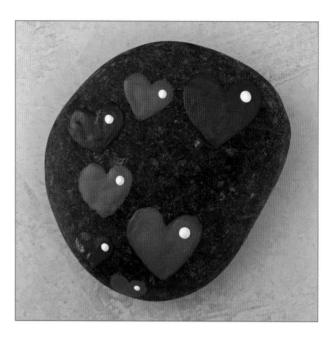

Step 4 As you work your way across the surface of the rock, let sections of the paint dry completely before handling the rock to access other sections. Most acrylic paint takes up to 10 minutes to dry enough for handling. Once your main pattern-themed images are completed, you can fill in negative spaces with dot art.

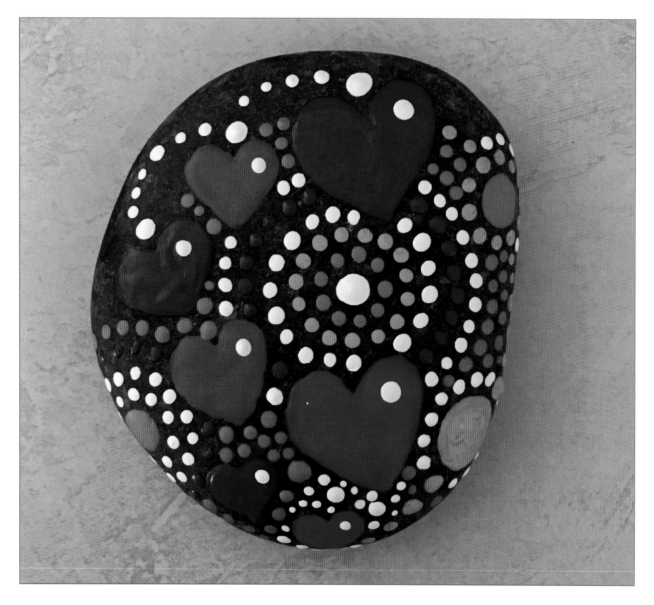

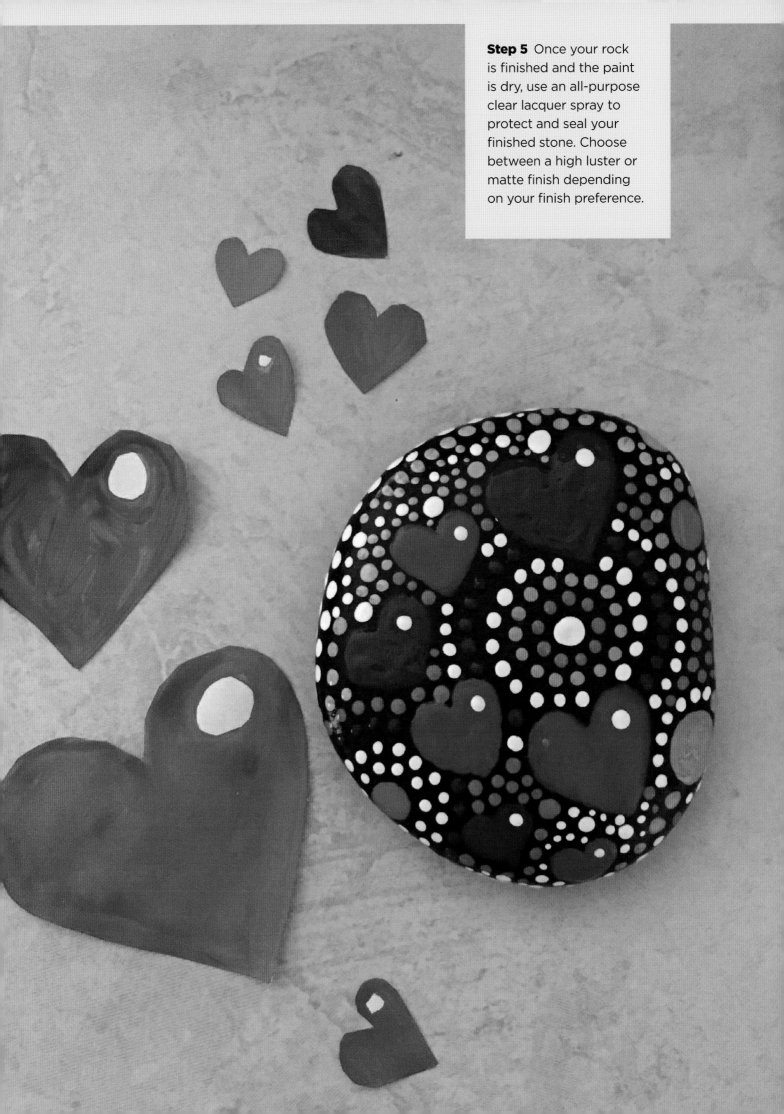

Step 5 Once your rock is finished and the paint is dry, use an all-purpose clear lacquer spray to protect and seal your finished stone. Choose between a high luster or matte finish depending on your finish preference.

Flowers

with MARGARET VANCE

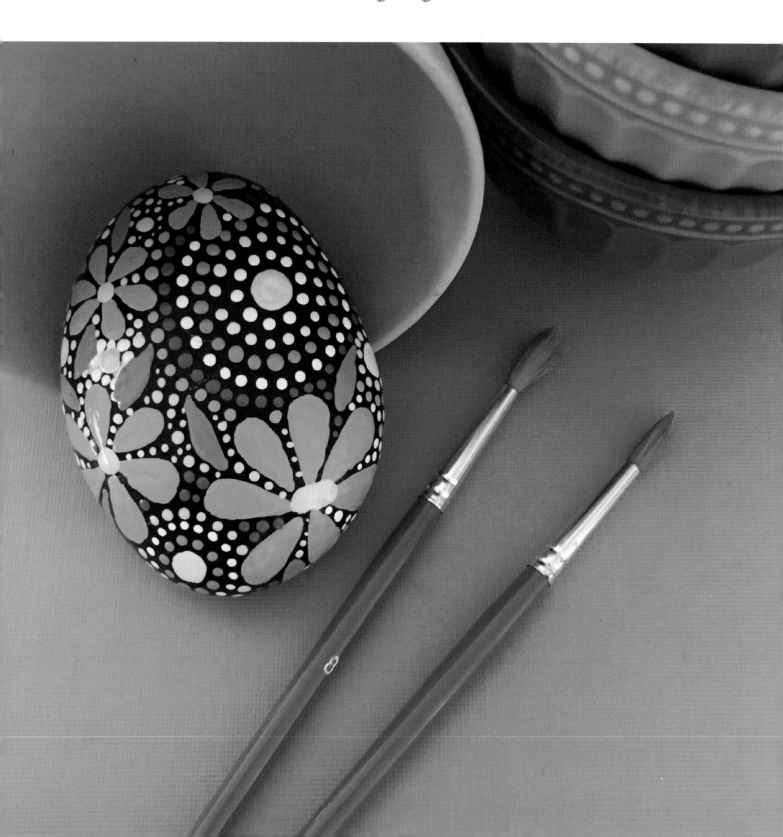

Step 1 Choose a flat, smooth rock with a shape, size, texture, and color you like. Remember, your rock should be free of dirt and completely dry. Determine a color scheme, keeping in mind that pattern drawings repeat shapes, colors, and designs. This color combination of simple bowls inspired a garden theme of blue, yellow, and green.

Step 2 Find a starting point for your pattern using the size, surface texture, and shape of the rock to guide your design. Next begin to place a pattern of flowers on the rock.

Step 3 Color your rock using varied shades of blue and yellow—or stay with the same blue and yellow. Use different shades of blue, yellow and green to accent the design. Remember to let sections of the paint dry completely before handling the rock to access other sections. I often work on two or more rocks at a time so I can maximize my paint usage and allow one rock to dry while I work on another.

Step 4 Once your pattern-themed images are complete, you can leave them on their own or fill in the negative spaces with dot art.

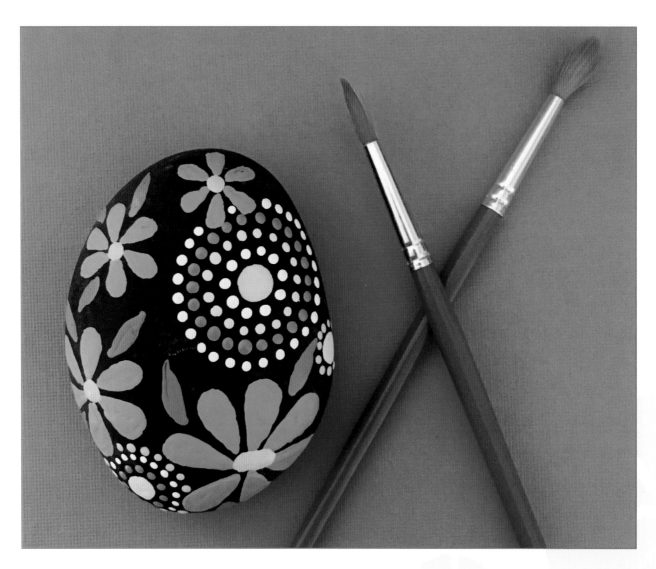

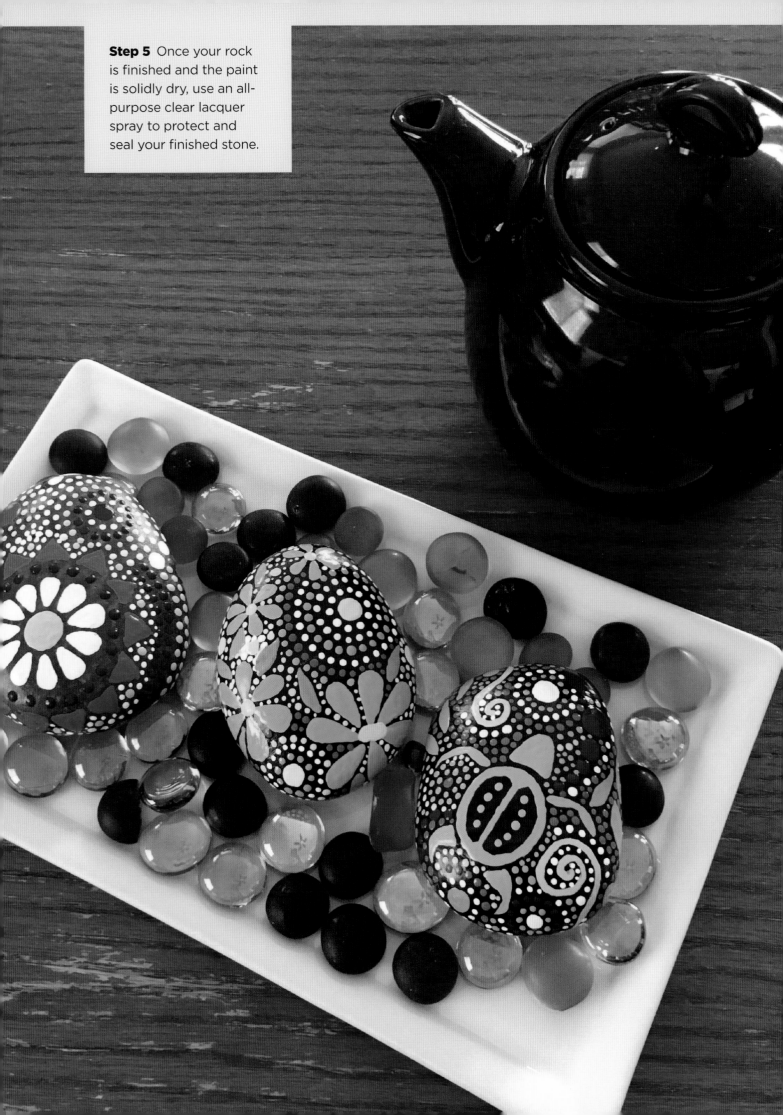

Step 5 Once your rock is finished and the paint is solidly dry, use an all-purpose clear lacquer spray to protect and seal your finished stone.

Petroglyphs

with MARGARET VANCE

Petroglyphs are Native American and indigenous Australian carvings that make wonderful sources of inspiration for your designs. Adding other elements like dot art, mandalas, and natural accents will enhance the design.

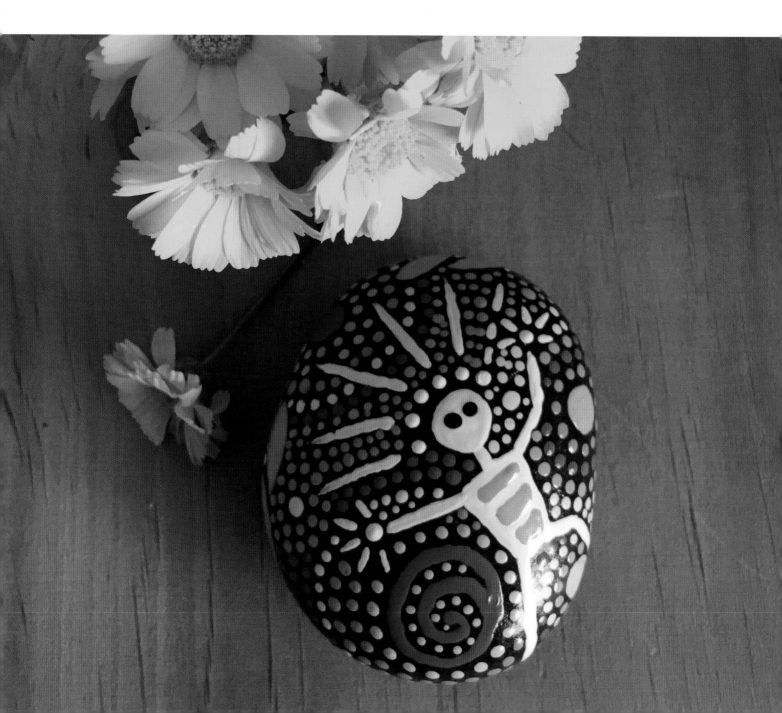

Step 1 Choose a flat smooth rock with a shape you like. The rock's shape, size, texture, and color can guide your color and design choices. Remember that your rock should be free of dirt and completely dry.

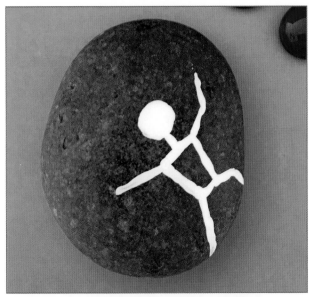

Step 2 Determine a color scheme. I am using a natural palette to mimic the setting where ancient petroglyph art is often located with burnt oranges and dark yellows. Find a starting point for your petroglyph using the size, surface texture, and shape of the rock to guide your design. Using ancient designs as a guide, I set my dancing figure at a slight angle to help communicate movement and energy.*

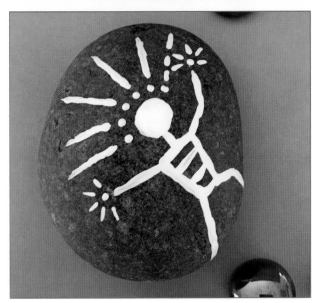

Step 3 Your figure can be as elaborate or as simple as you want. You can accent the head-dress, garment, hands, feet, and facial features.

*For this petroglyph reference, I used A Field Guide to Rock Art Symbols of the Greater Southwest by Alex Patterson, Johnson Printing Company © 1992 by Alex Patterson.

Step 4 Once your petroglyph is set, you can complete your rock design using other petroglyph symbols such as sun designs, spirals, or handprints. Natural elements such as flowers and leaves are also nice additions. I like to use dot art mandalas as well.

Step 5 Be very careful to let sections of the paint dry completely before handling the rock to access other sections. It is easy to smudge and ruin finished sections if you skip this step.

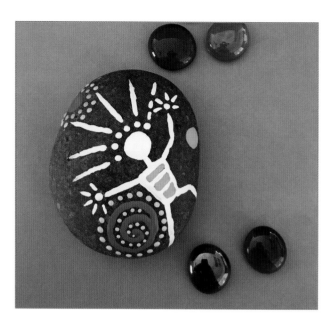

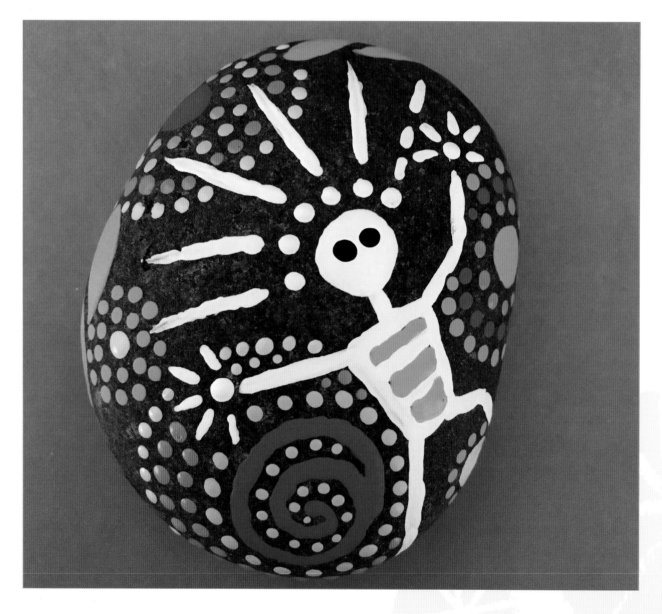

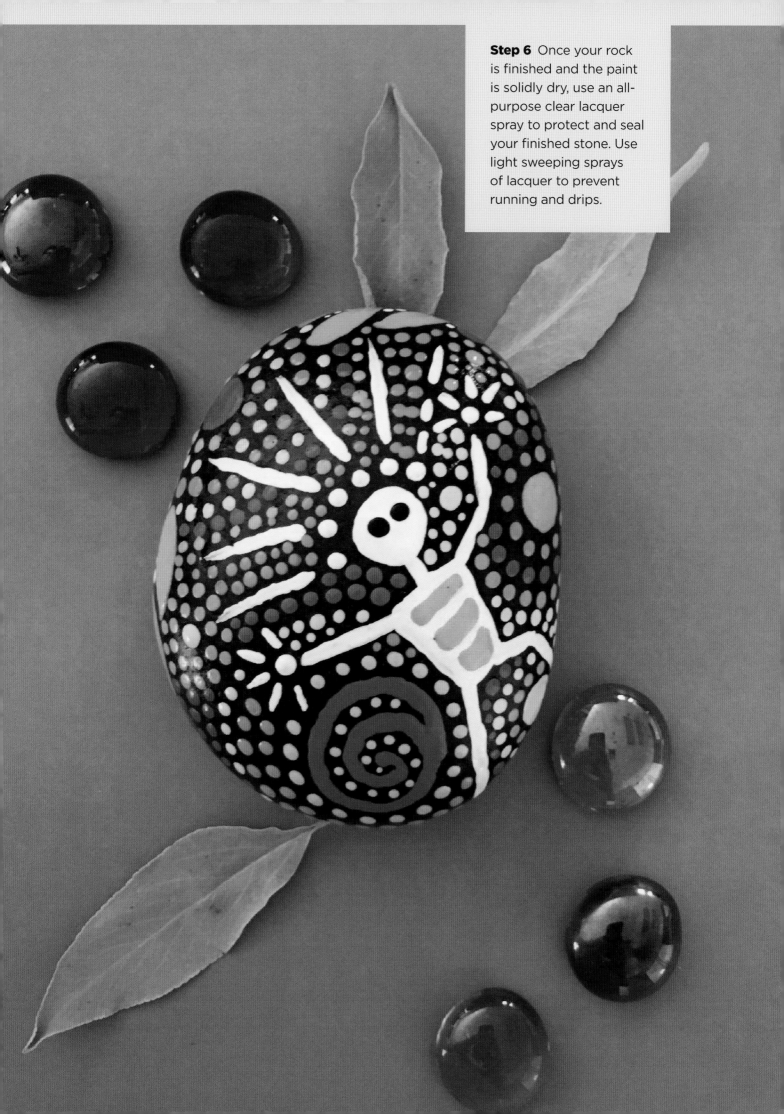

Step 6 Once your rock is finished and the paint is solidly dry, use an all-purpose clear lacquer spray to protect and seal your finished stone. Use light sweeping sprays of lacquer to prevent running and drips.

Dot PATTERN

with F. SEHNAZ BAC

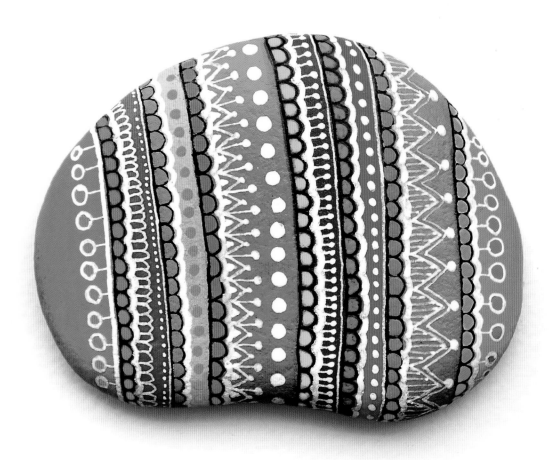

Step 1 Wash your stone well with water and let it dry. When the stone is completely dry, use a pencil to draw some vertical parallel lines directly on the natural surface of the stone.

Step 2 Use acrylic paints or inks and a round brush to paint the space between the parallel lines with different colors.

Step 3 After your paint dries completely, draw contour lines with a black fine-liner pen between your colored spaces.

Step 4 Next add details to your pattern. For every line, use a black fine-liner pen to add rows of semicircles or ovals. Fill in the semicircles and ovals with different colors to create a contrast with the background. Use fine-point paint pens to add color to small spaces.

Step 5 Now you can add detail to your design. Use white ink and a dip pen to add contours around each row, fill spaces with dots, add rows of triangles, or create lines. Add dots with contrast colors and contain them with white contour lines.

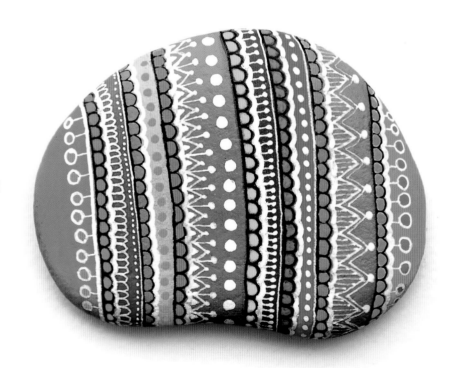

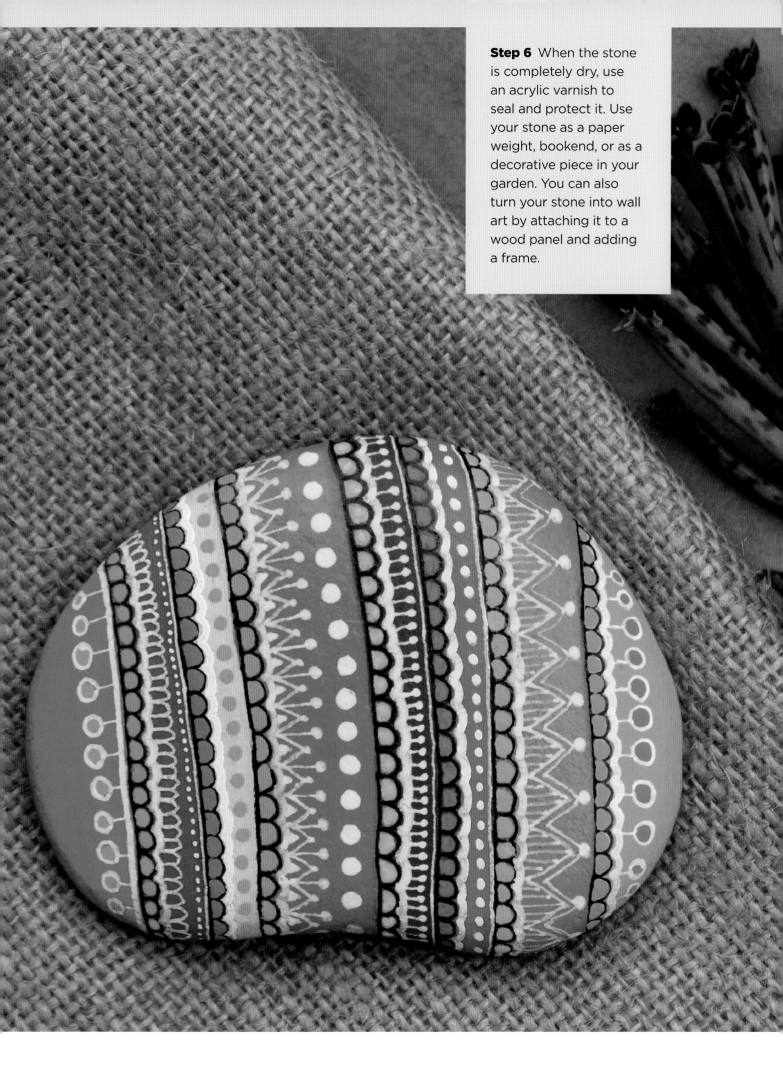

Step 6 When the stone is completely dry, use an acrylic varnish to seal and protect it. Use your stone as a paper weight, bookend, or as a decorative piece in your garden. You can also turn your stone into wall art by attaching it to a wood panel and adding a frame.

Garden PATTERN

with F. SEHNAZ BAC

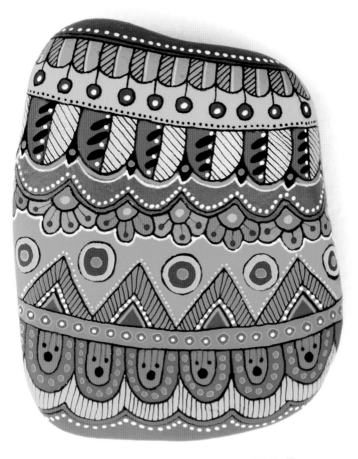

Step 1 Find a flat, smooth stone. Wash the stone well, and let it dry. The shape of the stone isn't important when painting patterns.

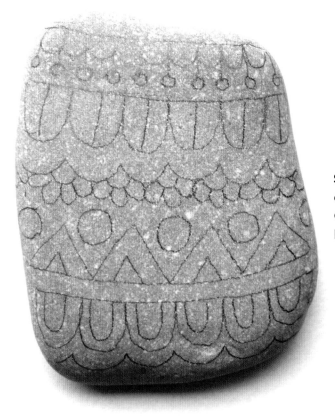

Step 2 Use a pencil to draw your pattern directly onto the natural surface of the stone. Create your pattern with semicircle rows, leaf-like motifs, flower parts, circles, or triangle rows.

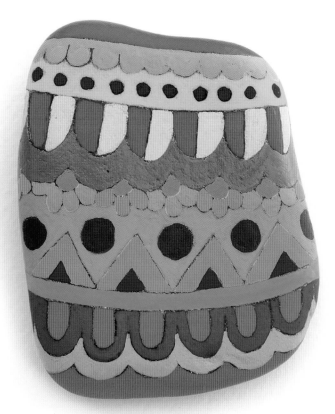

Step 3 Use acrylic paint and inks with round brushes to paint your pattern with multiple bright colors. For small areas, use paint pens.

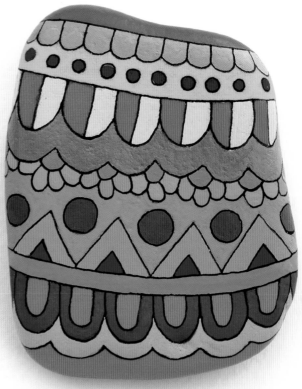

Step 4 When the paint is dry, use a black, fine-liner pen to add contour lines to your pattern.

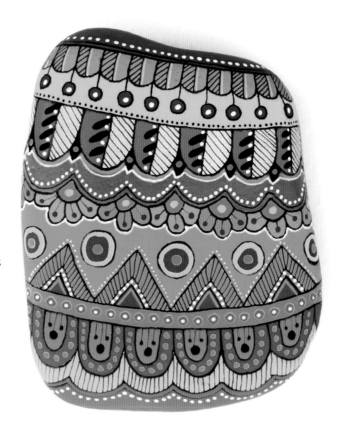

Step 5 Now it's time to add details. Once your contour lines are dry, you can add thin parallel lines inside leaf-like rows, or in semicircles to divide them in half. Add little black leaves, parallel lines to triangle rows, contour rows with contrast colors, or add small black or white dots between rows. Let dry.

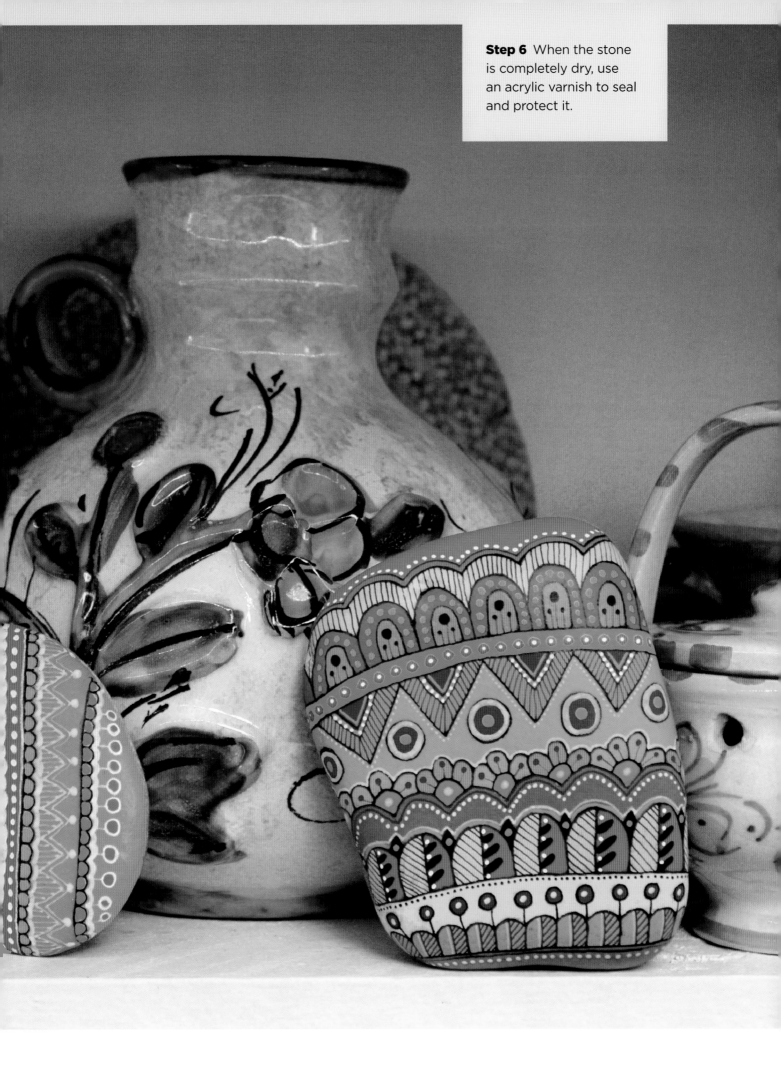

Step 6 When the stone is completely dry, use an acrylic varnish to seal and protect it.

Striped
FEATHER

with MARISA REDONDO

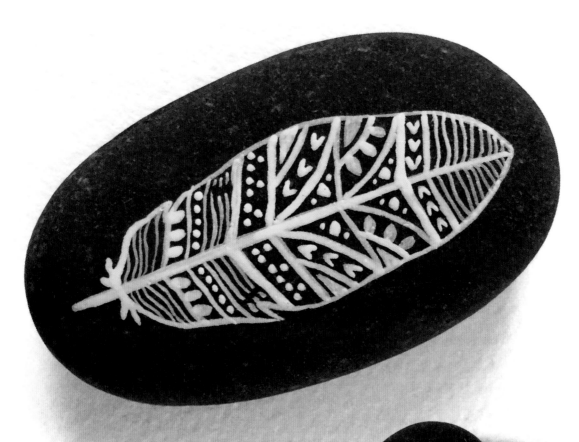

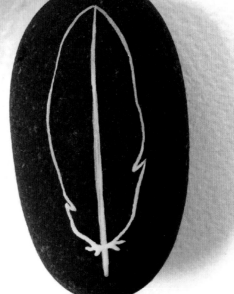

Step 1 Choose an oval rock. Apply a thin and even layer of varnish to your rock with a Filbert brush. Once the varnish is dry, paint a thin, centered line on your rock with the size 1 round paintbrush. Paint a feather tuft outline with a size 00 paintbrush. Use this brush for the remainder of the feather details.

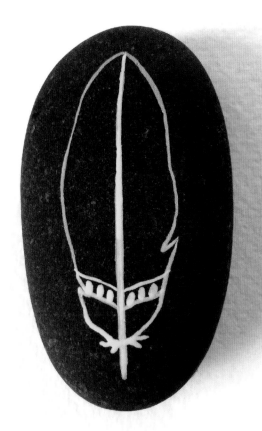

Step 2 Begin your feather details at the base of the feather.

Step 3 Continue to add small decorative patterns to your feather, divided by sections, and work up to the middle of the feather.

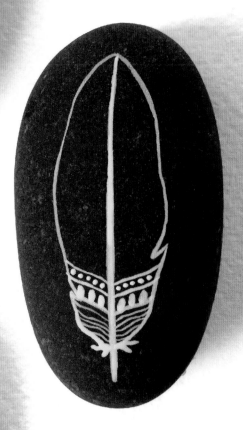

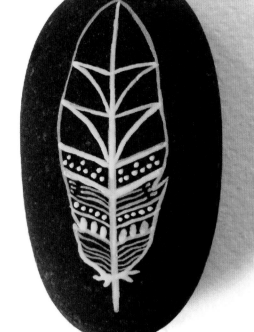

Step 4 Paint two triangular shapes at the center of the feather.

Step 5 Add a few more lines to further divide the triangular shapes into additional sections.

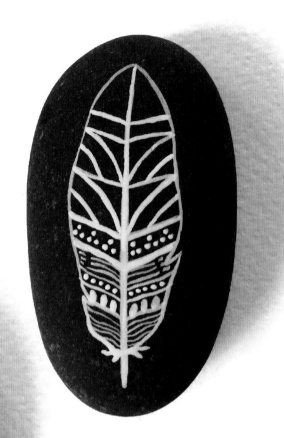

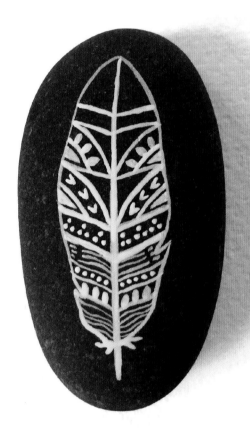

Step 6 Paint decorative details within each section of the design.

Step 7 Create your own unique feather by using various shapes (dots, triangles, stars).

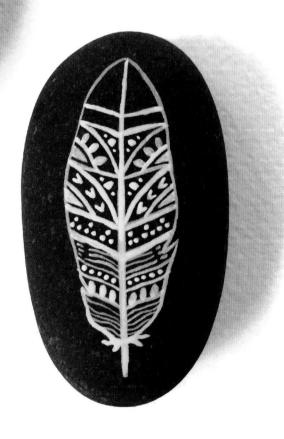

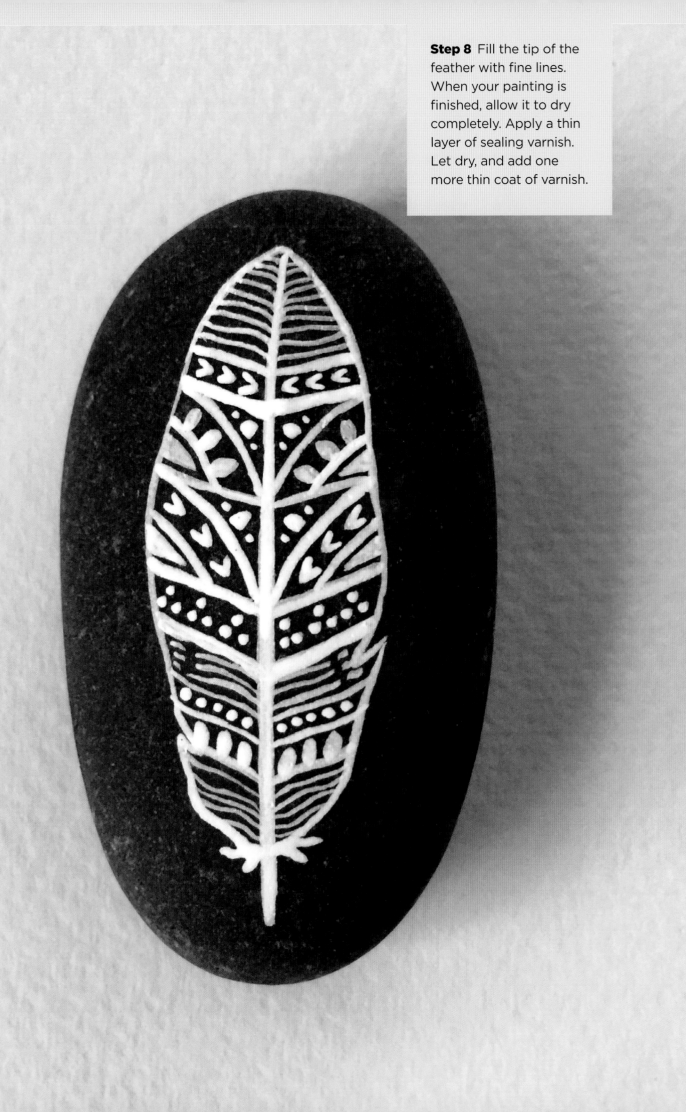

Step 8 Fill the tip of the feather with fine lines. When your painting is finished, allow it to dry completely. Apply a thin layer of sealing varnish. Let dry, and add one more thin coat of varnish.

Star
FEATHER

with MARISA REDONDO

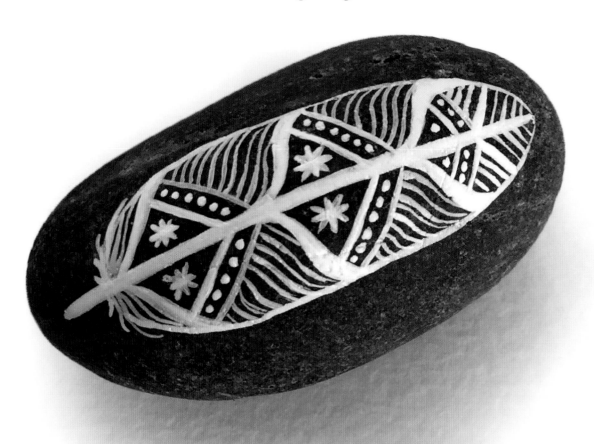

Step 1 Choose an oval rock. Apply a thin and even layer of varnish to your rock using a Filbert brush. Once the varnish is dry, begin by painting a thin line centered on your rock with a size 1 round paintbrush.

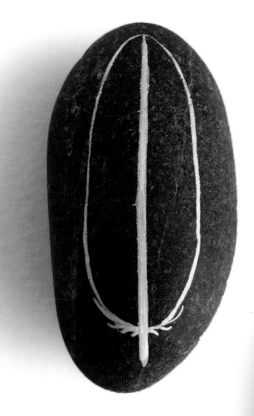

Step 2 Paint a feather tuft outline with a size 00 paintbrush.

Step 3 Paint V-shaped lines to divide the feather into sections.

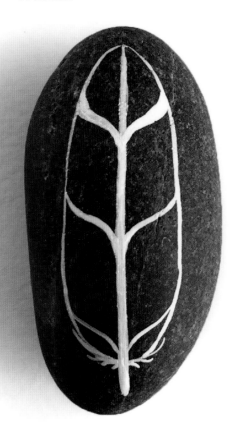

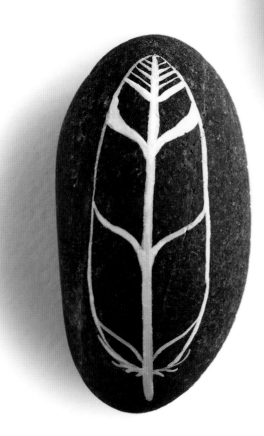

Step 4 Fill the tip of your feather with fine lines.

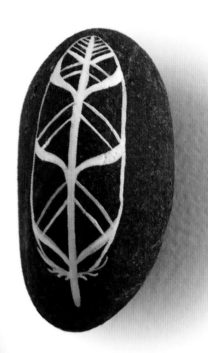

Step 5 Create a triangular shape within the feather by painting two lines in each section.

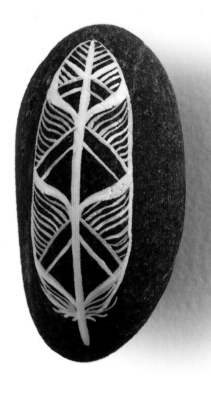

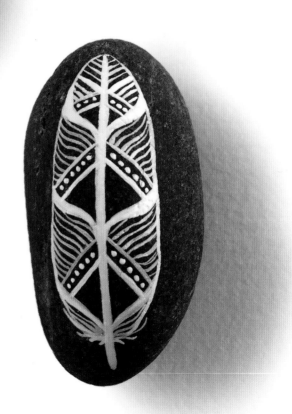

Step 6 Fill the area outside the triangles with fine, feather-like lines.

Step 7 Add dots to the triangle border.

Step 8 Lastly, paint a tiny star in each of the triangles. When your painting is finished, allow it to dry completely. Apply a thin layer of sealing varnish. Let dry, and add one more thin coat of varnish.

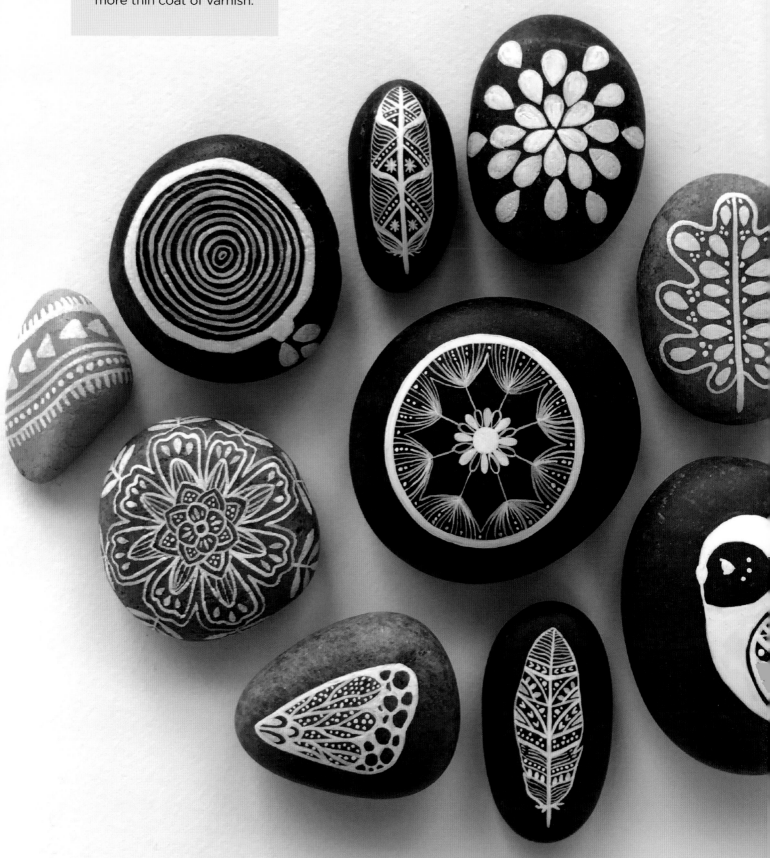

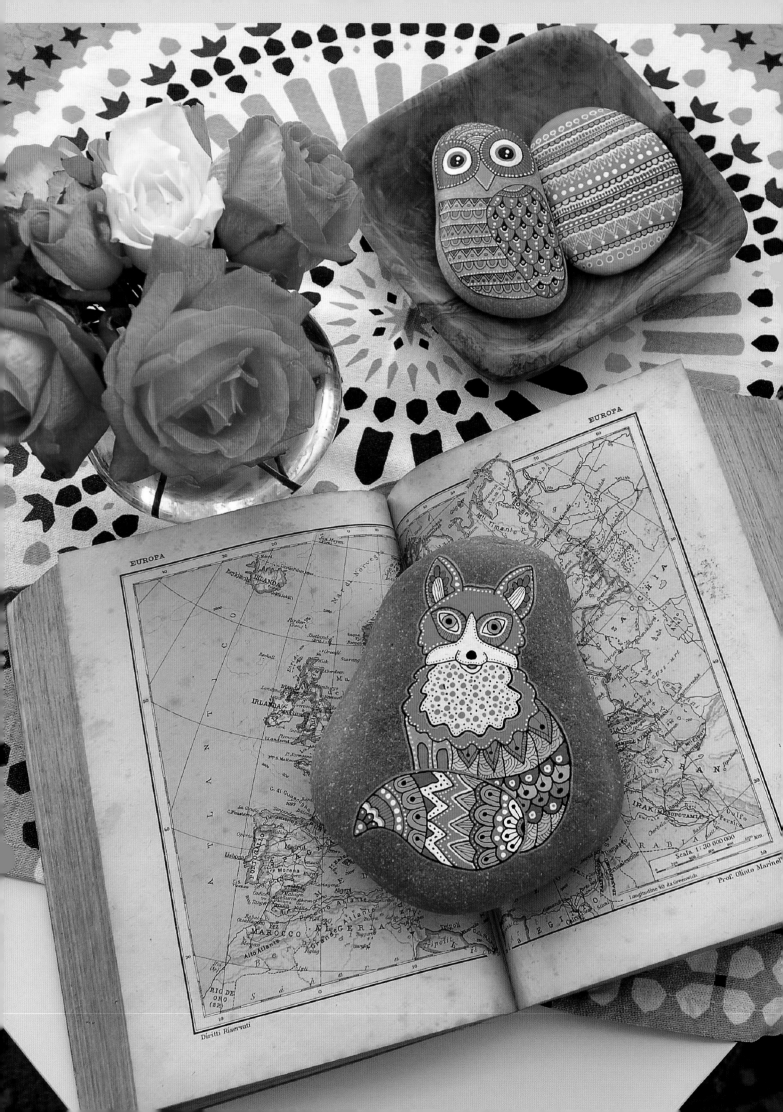

Animals

Dragonfly

with MARGARET VANCE

The dragonfly seems like a creature from another world. It symbolizes change and flexibility. This creature is the perfect inspirational symbol for decorating your rock. It is an ideal keepsake for someone in need or in the midst of change.

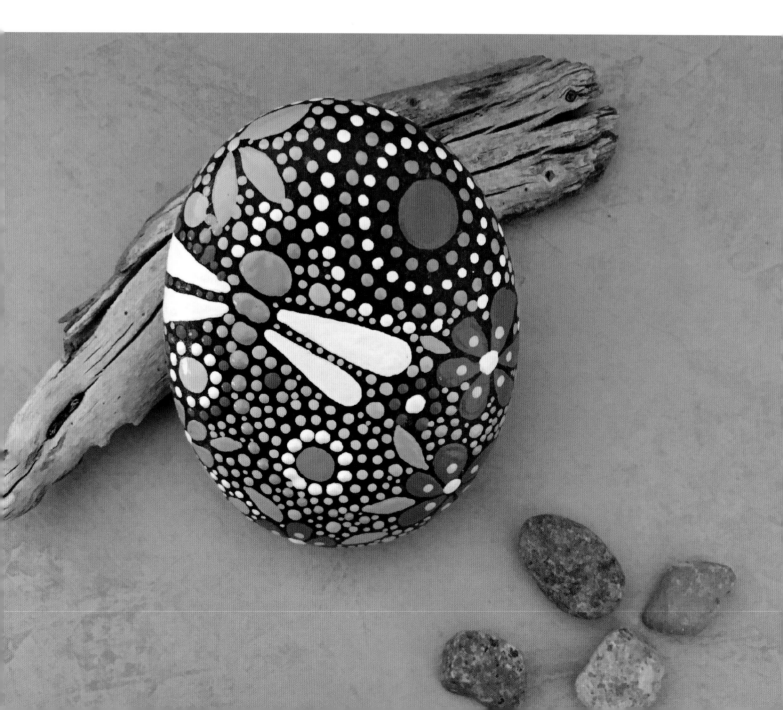

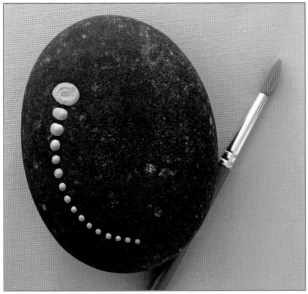

Step 1 Choose a flat, smooth rock with a shape you like. Remove any dirt from the rock and ensure that it is completely dry. The rock's shape, size, texture, and color can guide your color and design choices.

Step 2 Separate the dragonfly into circular parts: the largest part is the head, with smaller circles for the body and tail. In nature, dragonflies come in a variety of beautiful color combinations. Surrounding your dragonfly with flowers and mandala images will help you choose your dragonfly's colors.

Step 3 Next add wings near the body and two small circles for eyes. You can vary colors to make certain parts of the dragonfly stand out, or keep the body, wings, and eyes the same to create a more minimalistic design.

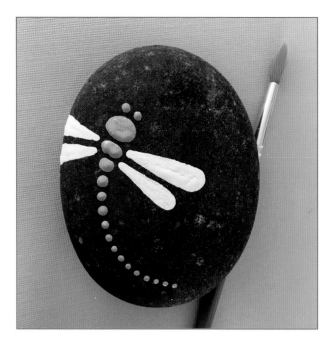

Step 4 Surround the dragonfly with flowers, mandalas, and other natural elements. The position of your dragonfly on the rock will help you decide where to place other decorative elements. Remember to let sections of paint dry completely before handling the rock to access other sections.

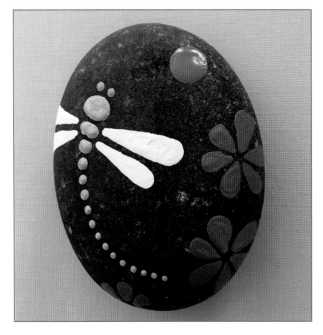

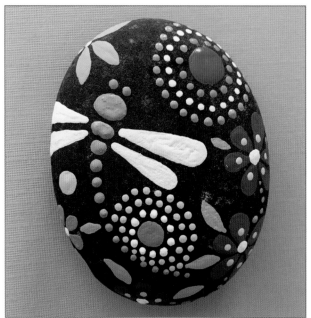

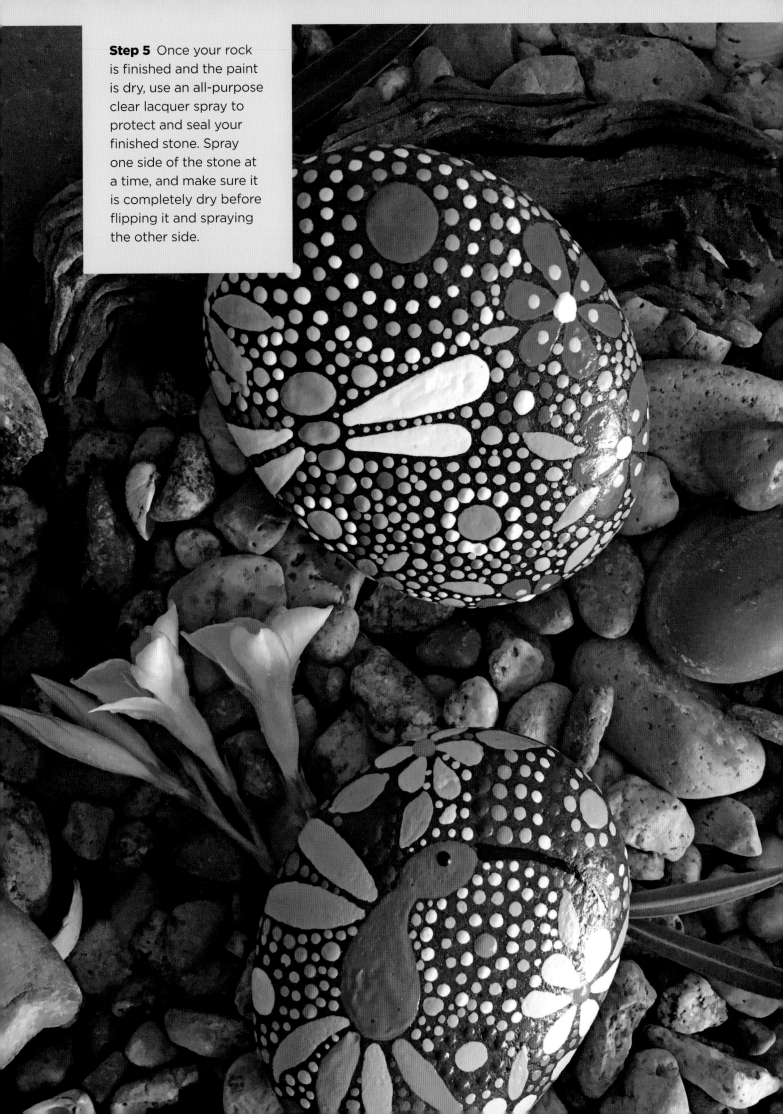

Step 5 Once your rock is finished and the paint is dry, use an all-purpose clear lacquer spray to protect and seal your finished stone. Spray one side of the stone at a time, and make sure it is completely dry before flipping it and spraying the other side.

Hummingbird

with MARGARET VANCE

Hummingbirds are one of my favorite creatures. Happily darting about the garden, they are flying jewels of joy. Their varied colors make hummingbirds the perfect subject for rock art.

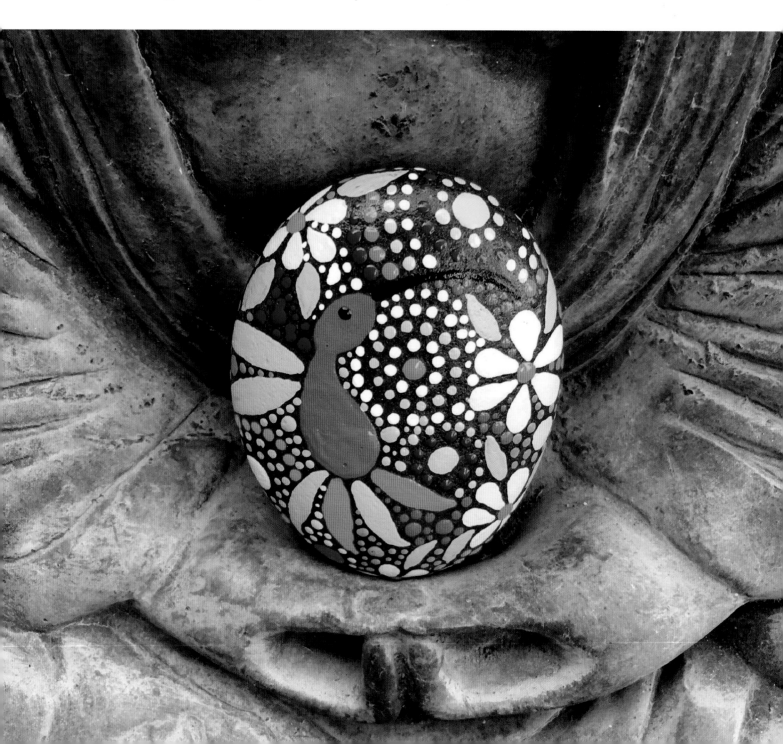

Step 1 Choose a flat, smooth rock with a shape you like. Remove any dirt from the rock and ensure that it is completely dry. The rock's shape, size, texture, and color can guide your color and design choices.

Step 2 Start by creating the head and body placement of the hummingbird. Make sure to allow room around your hummingbird for accents to the scene. It doesn't matter which color palette you choose—the hummingbird will display it beautifully! I like to use similar colors for the body and head to help distinguish the outline of the hummingbird, and then use a variety of different but similar hues for the wings and tail feathers.

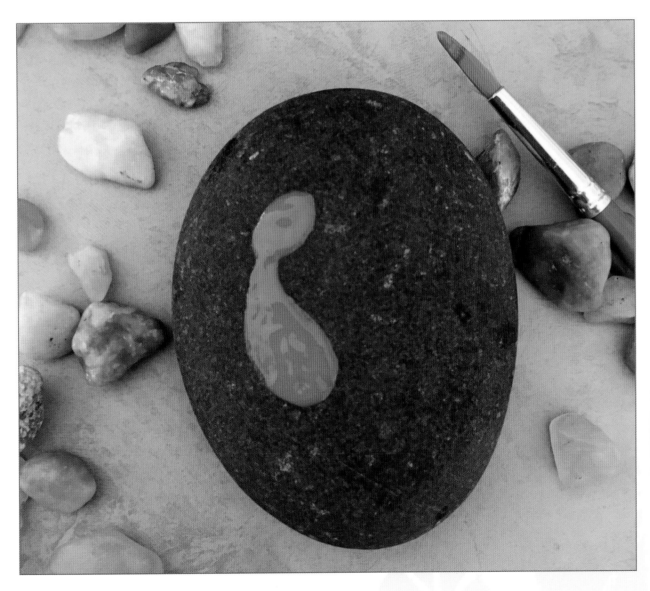

Step 3 Next, you will add wings to the back of the body and tail feathers to the bottom of the body.

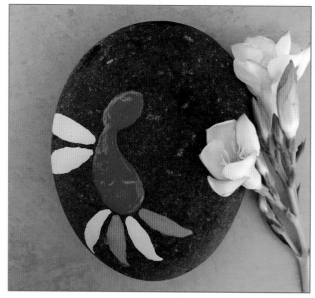

Step 4 When the paint on the hummingbird's head is completely dry, and you are satisfied with the color tones, use black paint to place the eye of the hummingbird on the head and a long beak extending from the head.

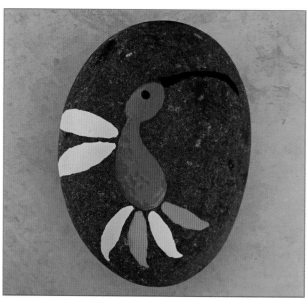

Step 5 Next, create the hummingbird's garden using flowers, mandalas, sun images, and other natural elements. Remember to let each section of paint dry completely before handling the rock to access other sections.

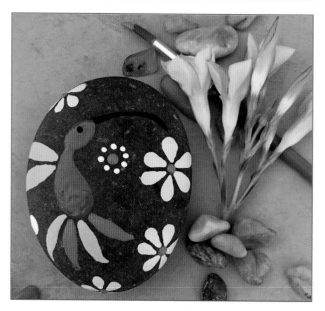

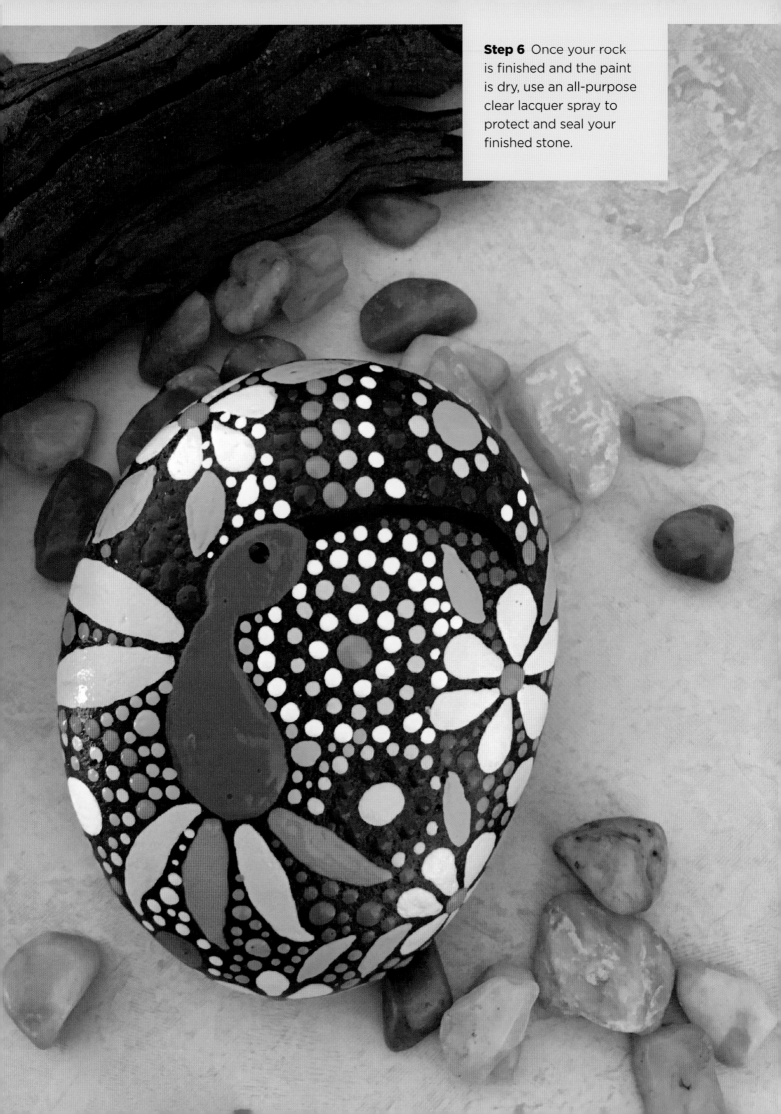

Step 6 Once your rock is finished and the paint is dry, use an all-purpose clear lacquer spray to protect and seal your finished stone.

Turtle

with MARGARET VANCE

Painting on rocks is as old as mankind. Petroglyphs are great sources of inspiration for your rock designs. This sea turtle was inspired by a miniature version of a petroglyph.

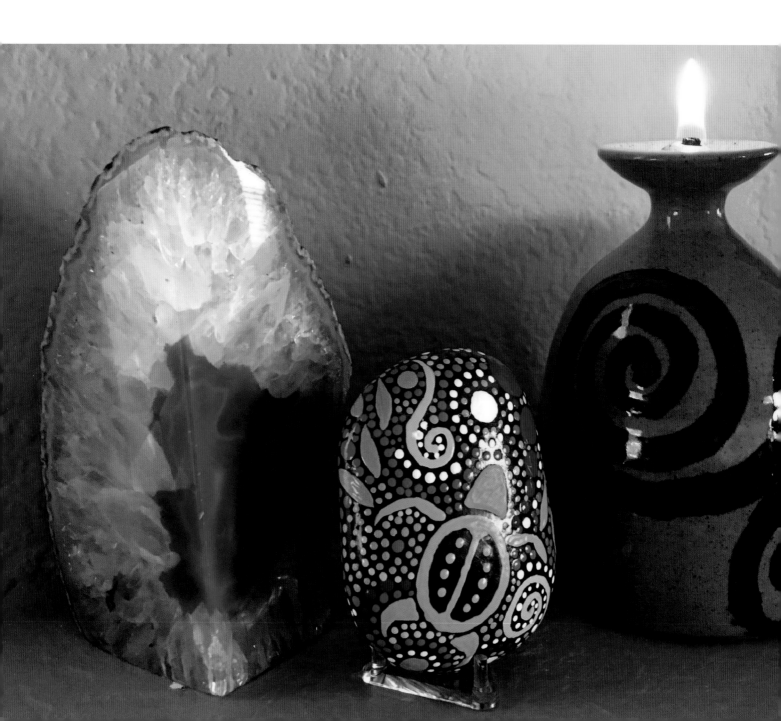

Step 1 Choose a flat smooth rock with a shape you like. The rock's shape, size, texture, and color can guide your color and design choices. The rock should be free of dirt and completely dry.

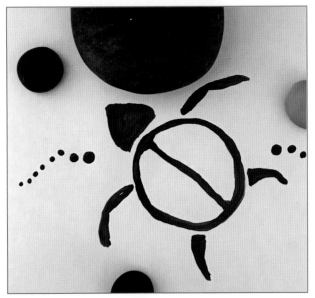

Step 2 Determine a color scheme. This sea turtle petroglyph will use blue ocean tones. Practice your design on paper until you arrive at the shape and contours you like.

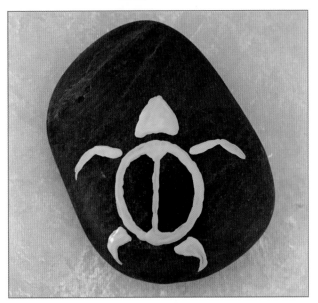

Step 3 Find a starting point for your petroglyph using the size, surface texture, and shape of the rock to guide your design. Your sea turtle design can be simple or more detailed. You can add dots, stripes, or other geometric designs to the turtle's back, or let the color of the stone determine the turtle's color.

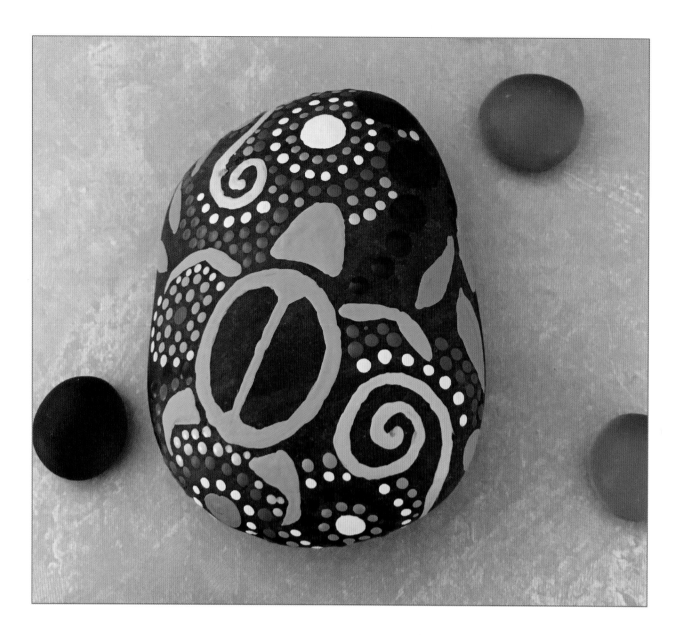

Step 4 Once your sea turtle petroglyph is set, you can complete your rock design using other petroglyph symbols such as sun designs, spirals, fish, or dots. Natural elements such as swirls of water or kelp are also nice additions.

Step 5 Be very careful to let each section of the paint dry completely before handling the rock to access other sections. Most acrylic paint takes up to 10 minutes to dry enough for handling.

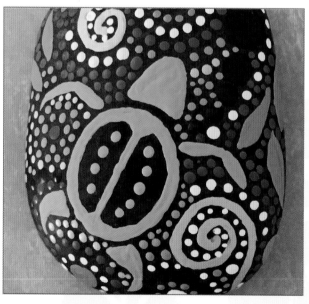

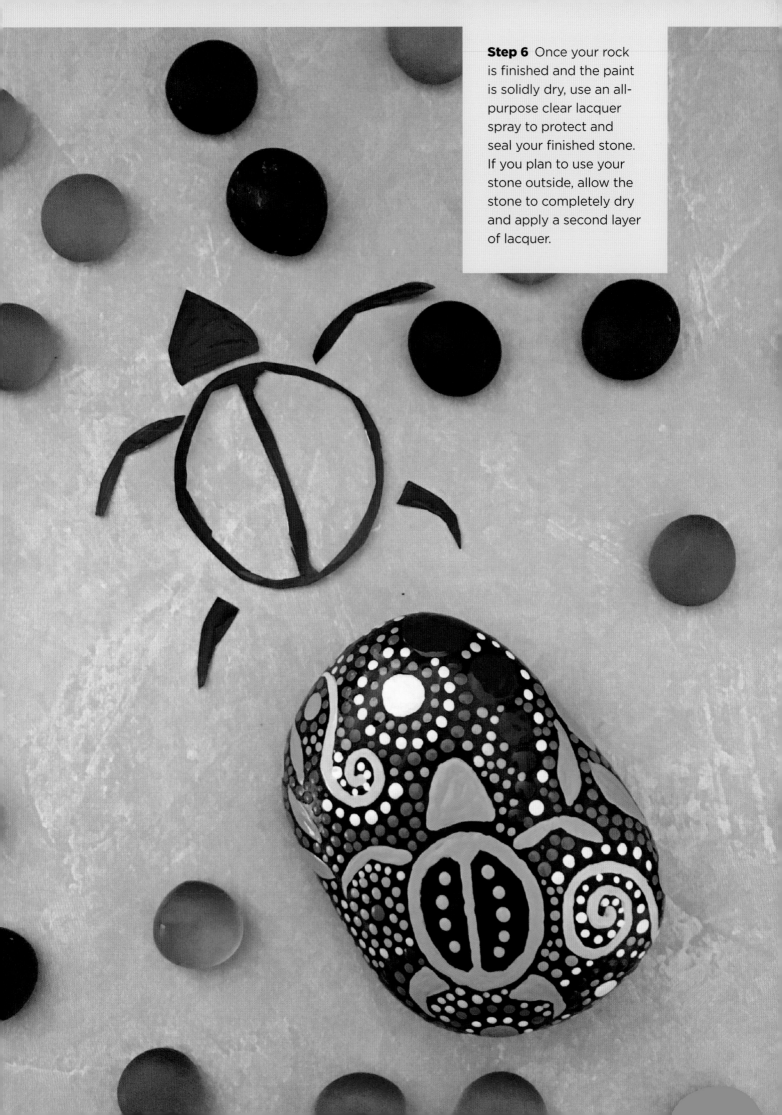

Step 6 Once your rock is finished and the paint is solidly dry, use an all-purpose clear lacquer spray to protect and seal your finished stone. If you plan to use your stone outside, allow the stone to completely dry and apply a second layer of lacquer.

Owl

with F. SEHNAZ BAC

Owls on stones are very happy objects to show when you arrange them with some pieces of driftwood to create a beautiful piece of wall art. You can also use your owl stone as a decorative object in your home: on a coffee table, your library shelf, or as a book stop or paperweight.

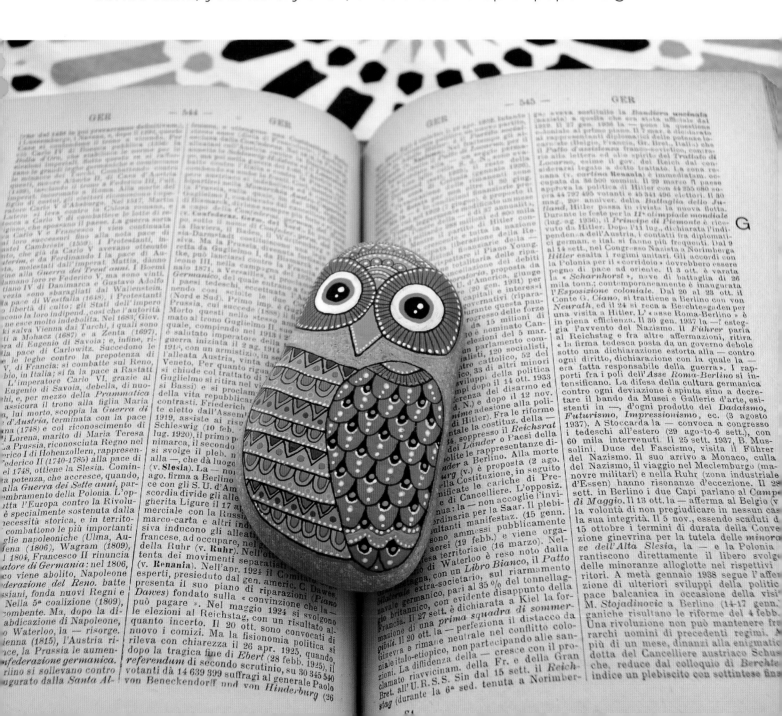

Step 1 For this project, you will need an oval-shaped stone. A stone with a smooth surface is best, because you can work directly on the natural surface of your stone.

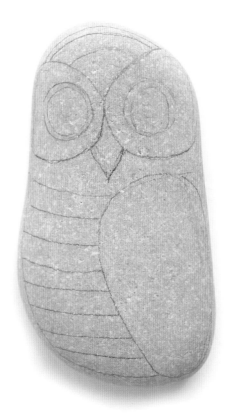

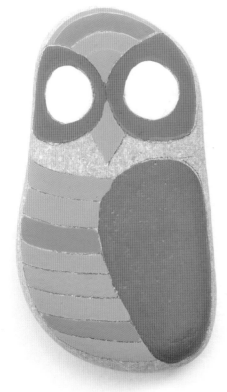

Step 2 Start to draw an owl sketch on your stone with a hard-tip pencil to create clean pencil lines. Use a soft art eraser if you want to correct your design. Make a rough sketch for now, you can add details after you fill in the larger parts with color.

Step 3 Begin to fill your design with acrylic paint or inks. Use thin, round brushes to work in small spaces. Choose bright, bold colors to give a contrast to your design.

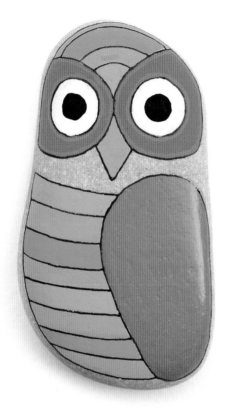

Step 4 Draw contour lines on all parts of your design with an extra-fine tip, black liner pen to achieve a clean and defined look.

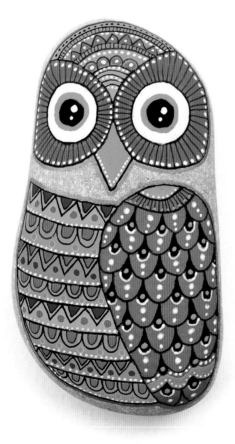

Step 5 Now you can add some details to your owl stone. First, use a pencil to fill the wing with semi leaf motifs. Fill the parallel lines of the body with geometric motifs such as triangles or semicircles. Add details to the head between parallel semicircles.

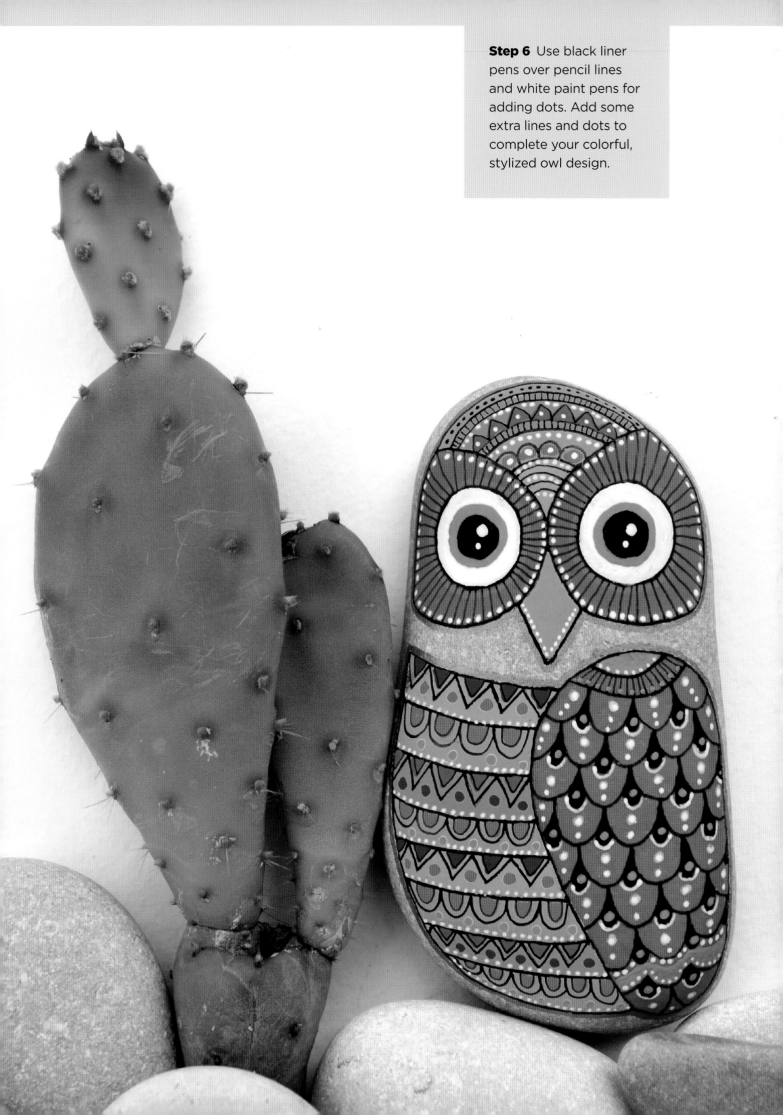

Step 6 Use black liner pens over pencil lines and white paint pens for adding dots. Add some extra lines and dots to complete your colorful, stylized owl design.

Fish

with F. SEHNAZ BAC

* ❋ * ❋ *

Fish stones with fresh, bold sea colors will give you a calm, meditative feeling. Try creating a row of fish stones with different colors for a decorative shelf in your home.

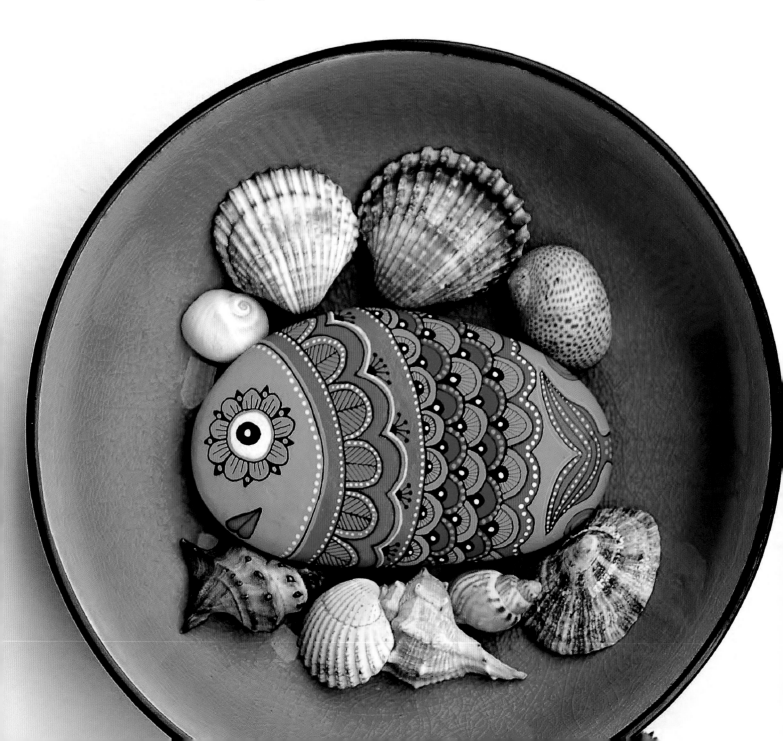

Step 1 Look for a smooth, flat stone with an oval shape that will allow you to work directly on the natural surface of the stone.

Step 2 Start to draw your sketch on the stone. For this fish design, separate the head and body of the fish with vertical, concave lines. Add a flower-shaped eye to the head. For the body, add semiovals to stylize the scales of the fish, and draw a tail.

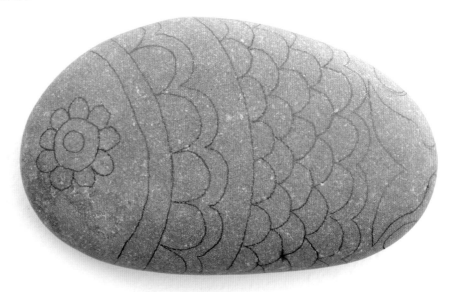

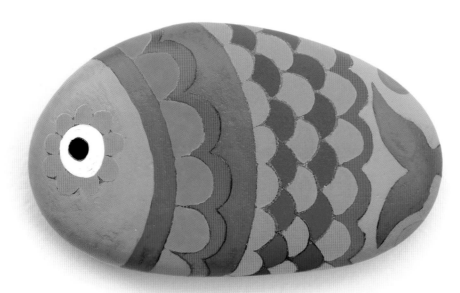

Step 3 Begin to fill your design with color. You can use acrylic paint or inks. Use a thin, round brush to color in small spaces. Choose bright, bold colors that give contrast to your design.

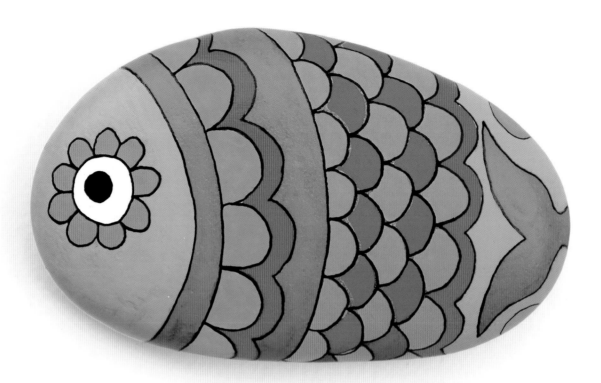

Step 4 Draw contour lines to all parts of your design with an extra-fine black liner pen to obtain a clean and defined look.

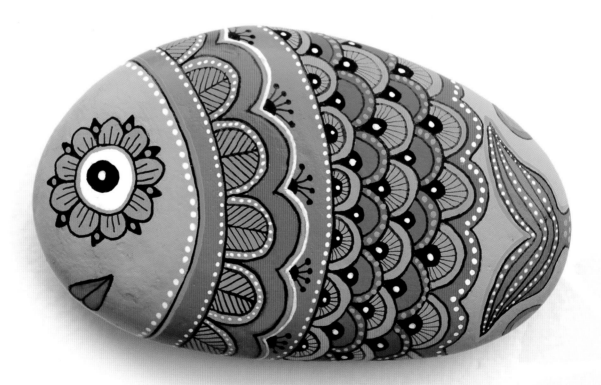

Step 5 Add details to your stone with black liner pens and white paint pens: extra lines and dots on the eye, scales, and tail.

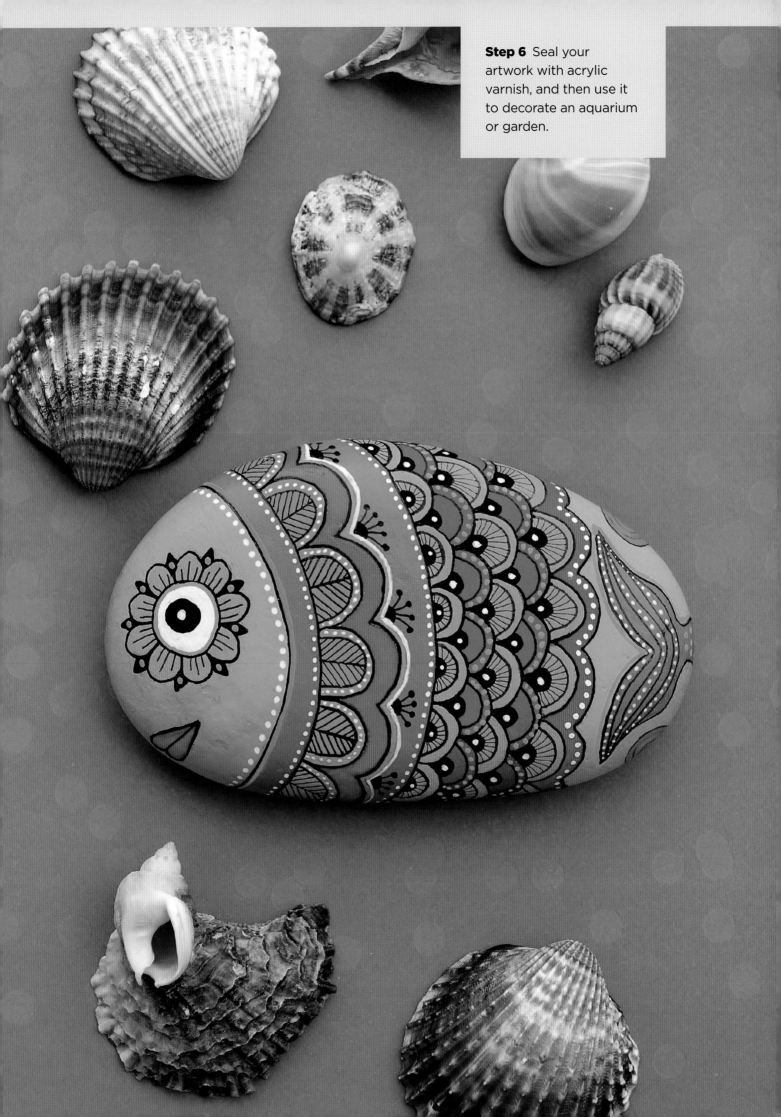

Step 6 Seal your artwork with acrylic varnish, and then use it to decorate an aquarium or garden.

Fox

with F. SEHNAZ BAC

Animal stones are a perfect choice for a children's room. They are playful, colorful, and the possibilities are endless. This mischievous fox would make the perfect companion for a playroom!

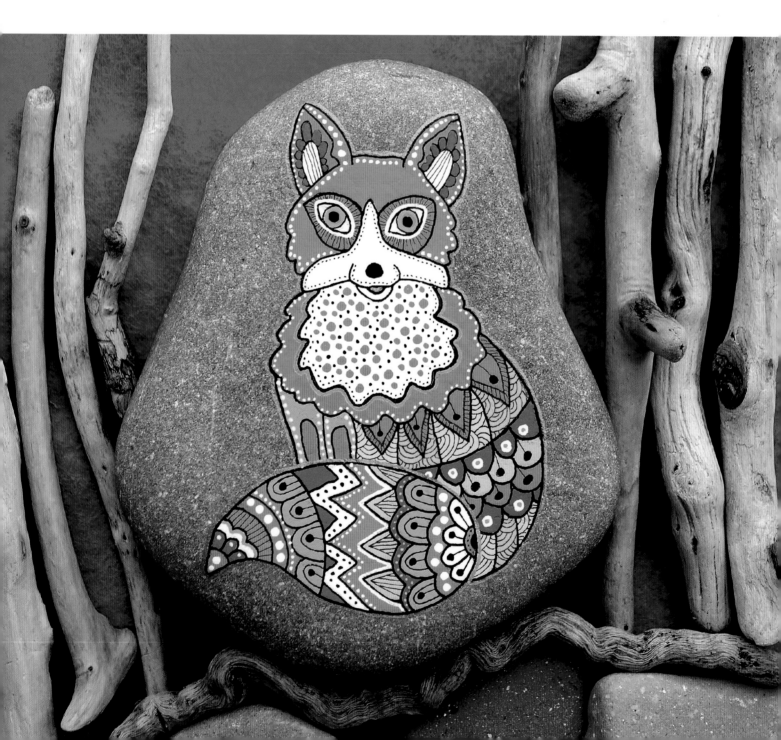

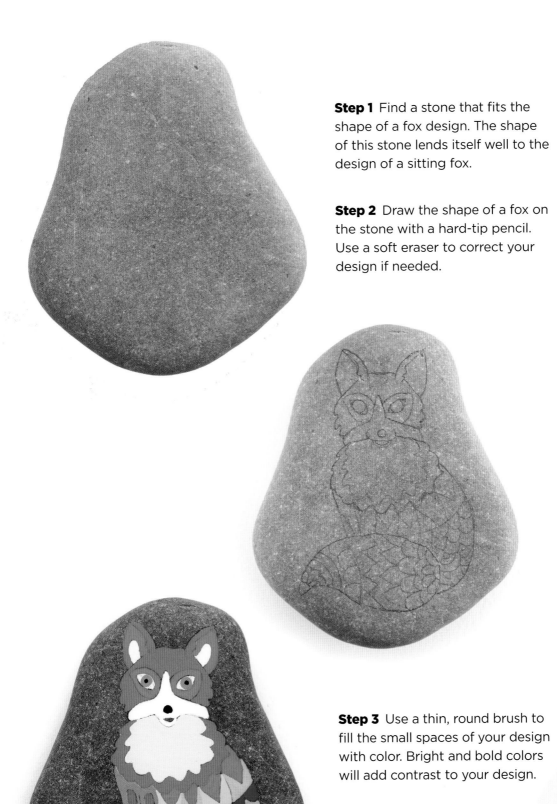

Step 1 Find a stone that fits the shape of a fox design. The shape of this stone lends itself well to the design of a sitting fox.

Step 2 Draw the shape of a fox on the stone with a hard-tip pencil. Use a soft eraser to correct your design if needed.

Step 3 Use a thin, round brush to fill the small spaces of your design with color. Bright and bold colors will add contrast to your design.

Step 4 Draw contour lines across your design with an extra-fine black liner pen to create a clean and defined look.

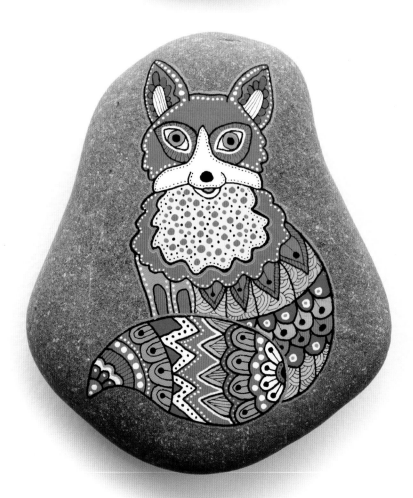

Step 5 Use black liner pens and white paint pens to add a whimsical appearance to your stone by adding extra lines and dots to stylize parts of your design.

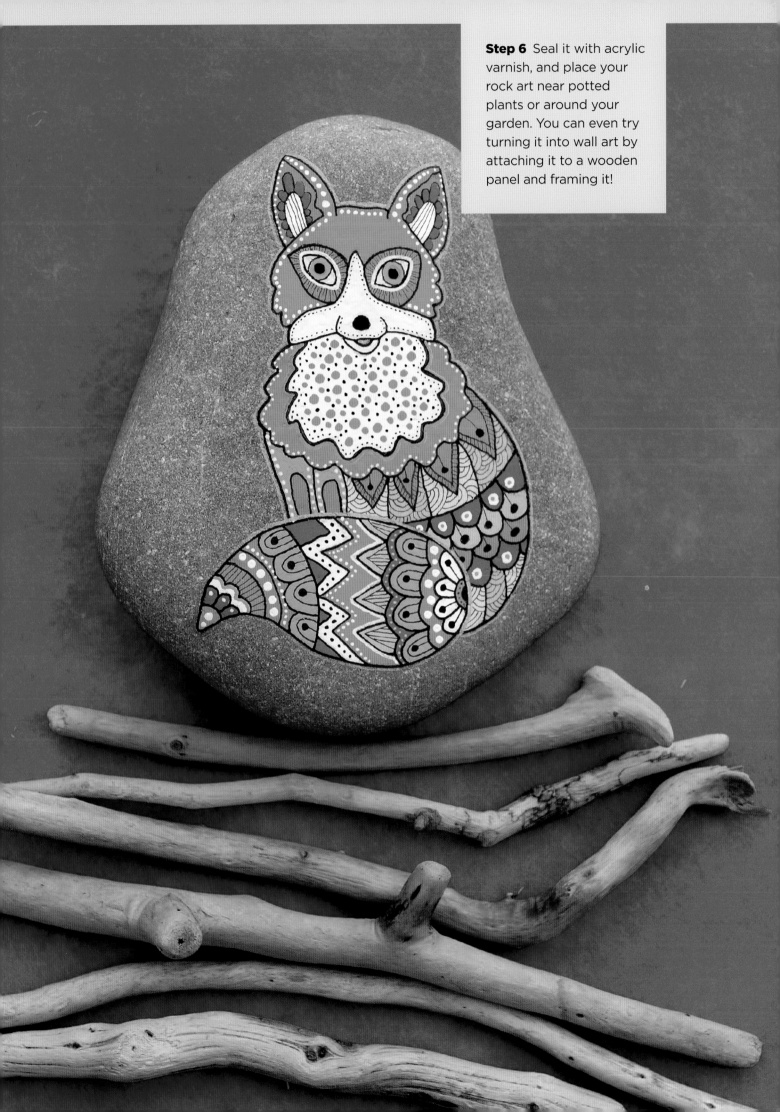

Step 6 Seal it with acrylic varnish, and place your rock art near potted plants or around your garden. You can even try turning it into wall art by attaching it to a wooden panel and framing it!

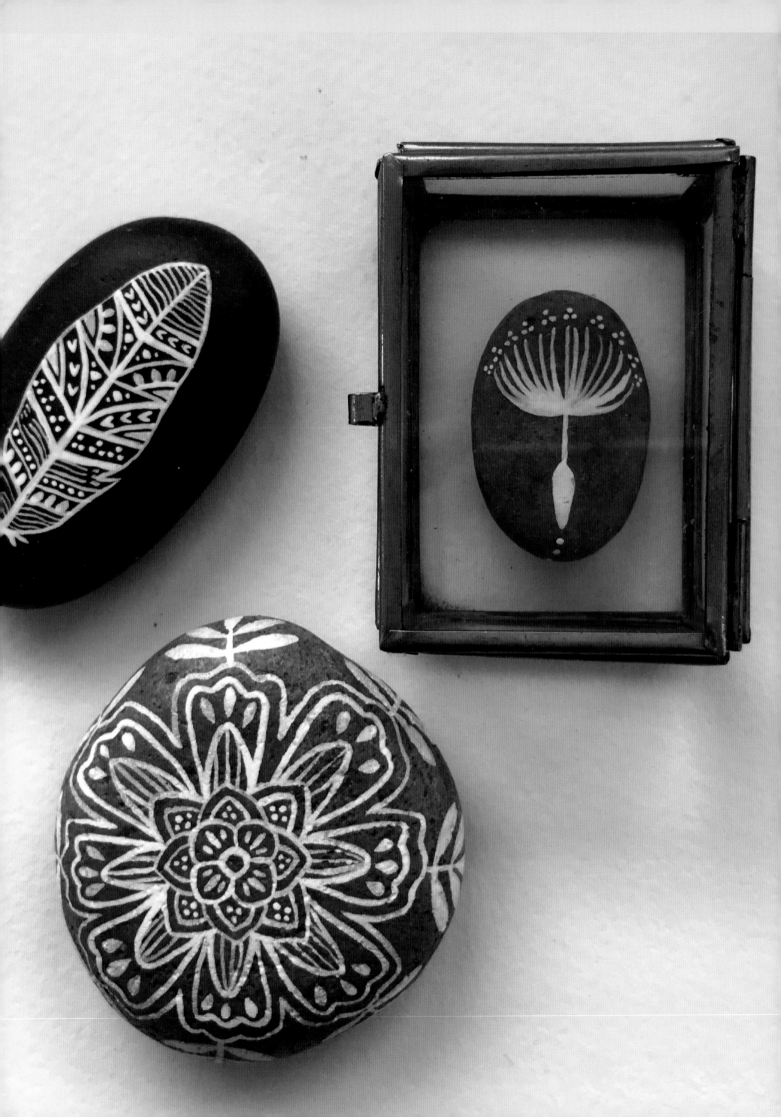

Nature

Raindrops

with MARISA REDONDO

Step 1 Use a Filbert paintbrush to apply a thin and even layer of varnish to your rock. Once the varnish is dry, use a size 00 paintbrush to paint three equally spaced raindrops.

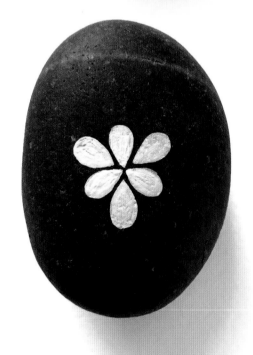

Step 2 In the space between each raindrop, paint another set of three more raindrops.

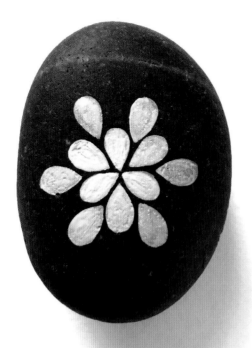

Step 3 Continue to add raindrops between each set.

Step 4 Repeat this process three or four times, or more if you prefer to fill the rock.

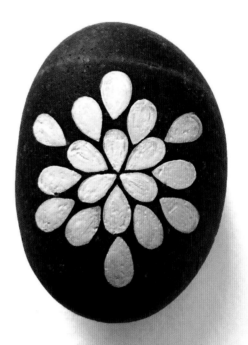

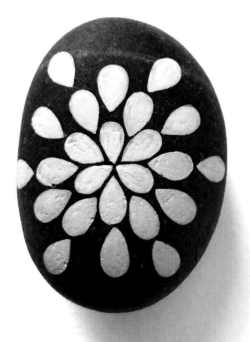

Step 5 Experiment and customize your rock by painting the drops in various sizes. Touch up and refine your painting with a thin second layer of paint. When your painting is finished, allow it to dry completely. Apply a thin layer of sealing varnish. Let dry, and add one more thin coat.

Tree RINGS

with MARISA REDONDO

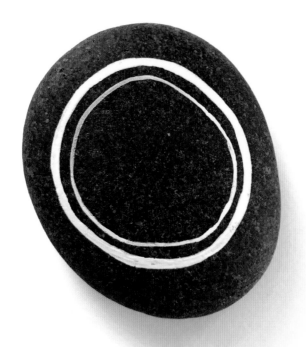

Step 1 Choose a round rock. Apply a thin and even layer of varnish to your rock with a Filbert paintbrush. Once the varnish is dry, paint a circle on your rock using a size 1 paintbrush. Leave a bit of space, and paint a second circle within the first using a 00 paintbrush.

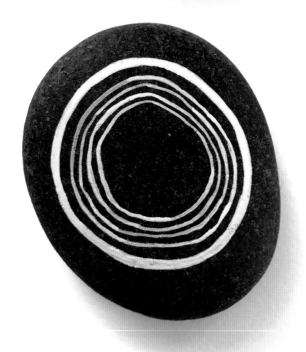

Step 2 Begin to paint circles within circles to look like a tree stump. The tree rings should be close together, but not touching.

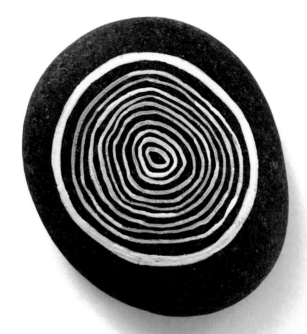

Step 3 Continue to paint circles within circles until you've filled your tree stump with rings.

Step 4 Paint a small branch from the outside of your circle.

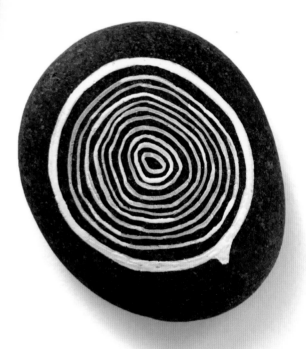

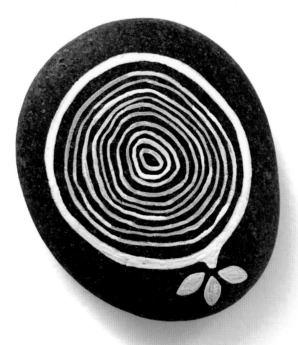

Step 5 Add three small leaves growing from the branch. Touch up and refine the painting with a thin second layer of paint, wherever necessary. When your painting is finished, allow it to dry completely. Apply a thin layer of sealing varnish. Let dry, and add one more thin coat.

Leaf

with MARISA REDONDO

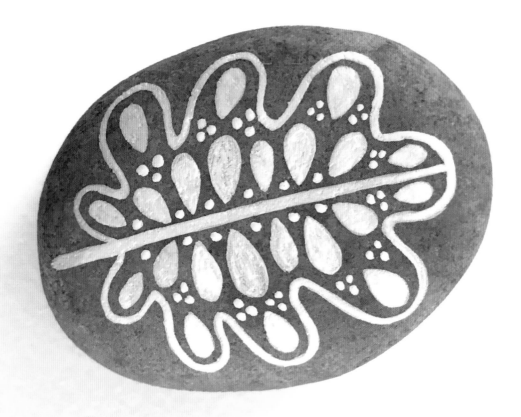

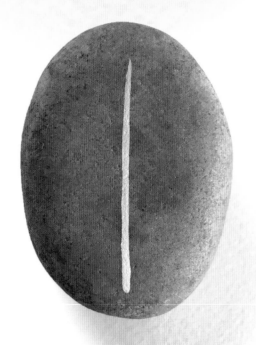

Step 1 Choose an oval rock. Apply a thin and even layer of varnish to your rock with a Filbert brush. Once the varnish is dry, paint a straight line, centered on your rock, with a size 1 round paintbrush.

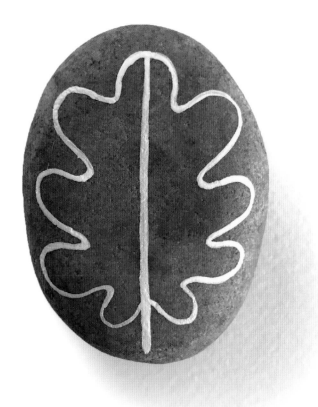

Step 2 Paint a simple, curvy leaf outline.

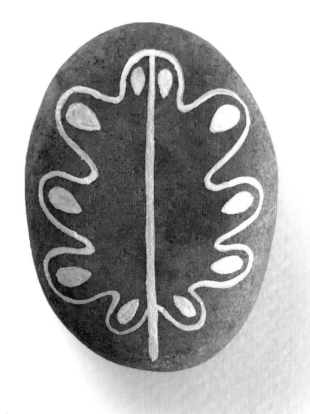

Step 3 Paint five teardrop shapes along each side of the leaf with a size 00 paintbrush.

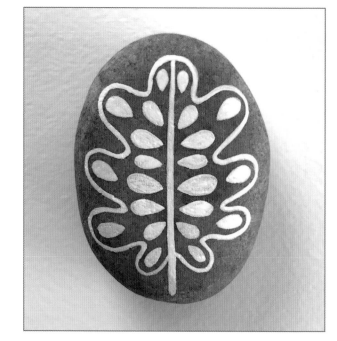

Step 4 Paint six teardrop shapes along each side of the center line of the leaf with a size 00 paintbrush.

Step 5 Fill empty spaces on your leaf with small dots.

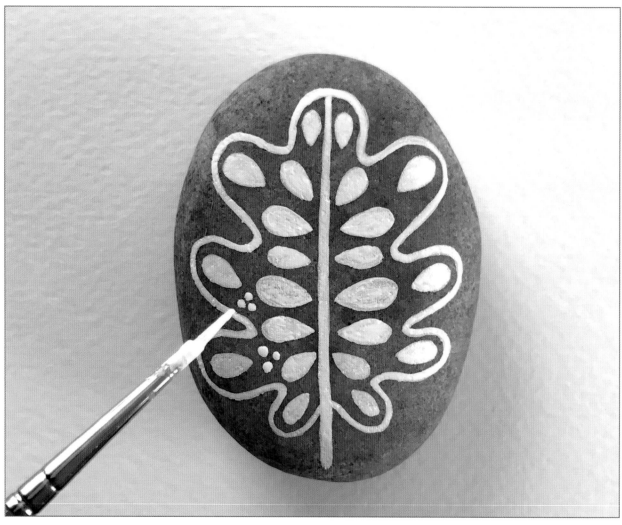

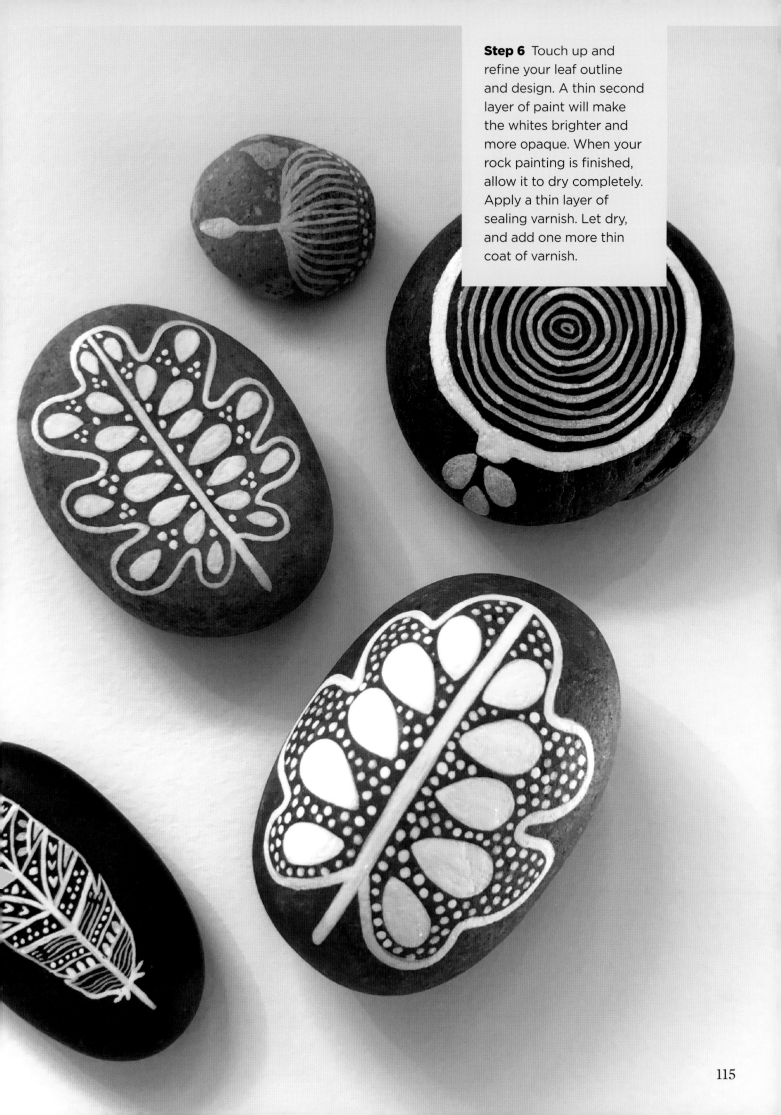

Step 6 Touch up and refine your leaf outline and design. A thin second layer of paint will make the whites brighter and more opaque. When your rock painting is finished, allow it to dry completely. Apply a thin layer of sealing varnish. Let dry, and add one more thin coat of varnish.

Butterfly WING

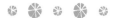

with MARISA REDONDO

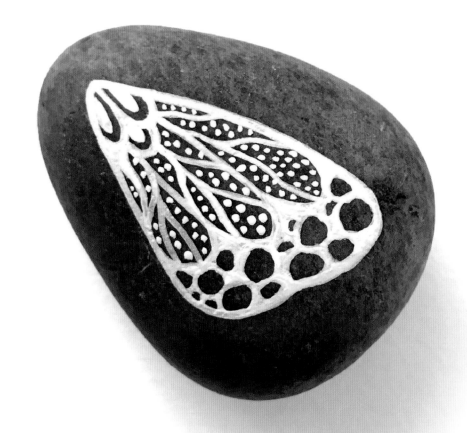

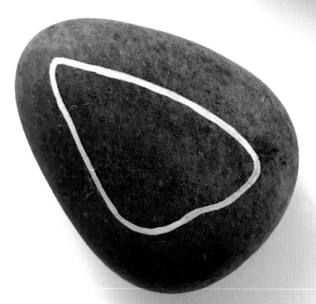

Step 1 Apply a thin and even layer of varnish to your rock with a Filbert paintbrush. When the varnish is dry, use your 00 paintbrush to paint a wing shape.

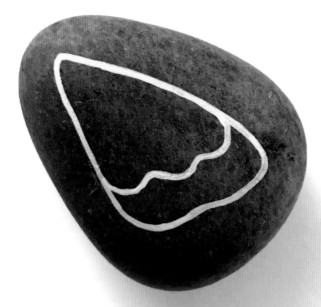

Step 2 Paint a curvy line at the wide end of your wing that has three rounded points.

Step 3 Add three small U-shaped lines at the narrow tip of the wing.

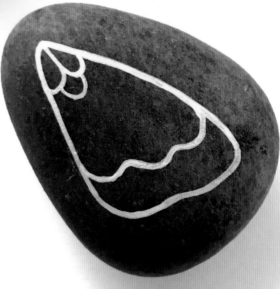

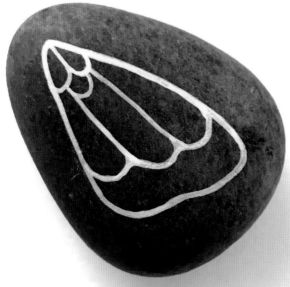

Step 4 Paint two lines down the center of the wing, connecting the tip to the curved line at the wide end of the wing.

Step 5 Paint circular shapes at the wide end of the wing. Once the space is filled, refine the design as you like.

Step 6 Fill the middle section of the wing with natural-shaped lines.

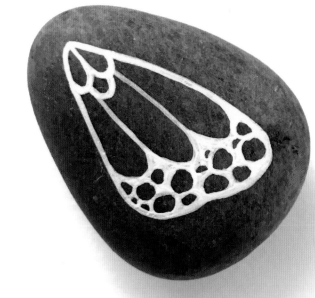

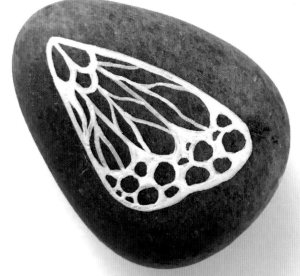

Step 7 Fill the middle section of the wing with tiny dots.

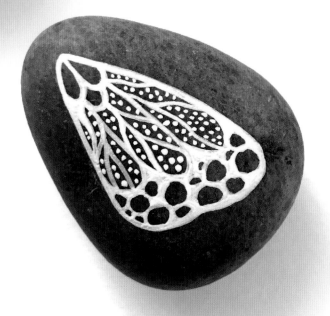

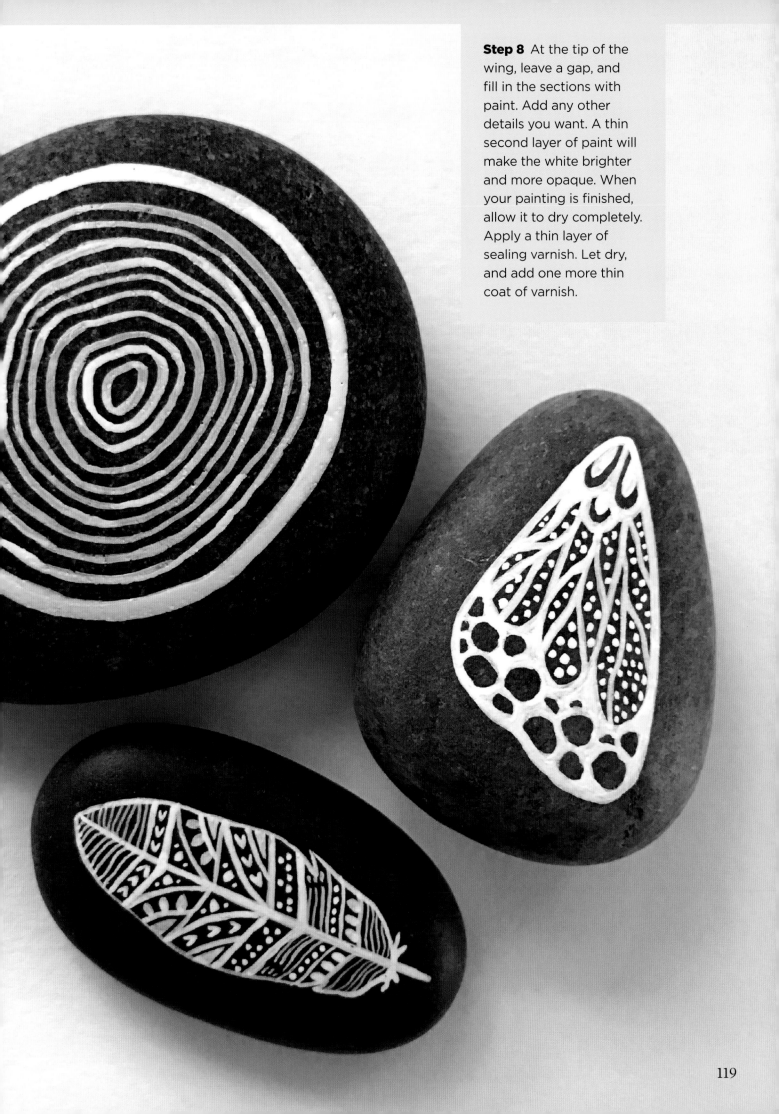

Step 8 At the tip of the wing, leave a gap, and fill in the sections with paint. Add any other details you want. A thin second layer of paint will make the white brighter and more opaque. When your painting is finished, allow it to dry completely. Apply a thin layer of sealing varnish. Let dry, and add one more thin coat of varnish.

Owlet

with MARISA REDONDO

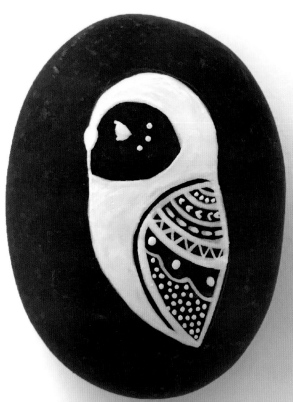

Step 1 Choose a smooth oval-shaped rock and, after cleaning and drying, apply a single thin coat of varnish. Once the rock is dry, use a pencil to lightly outline your owl shape. Using your smallest round brush, paint over the pencil outline of your owl.

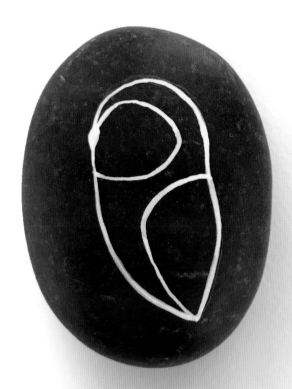

Step 2 Paint your owls face and wing, as shown.

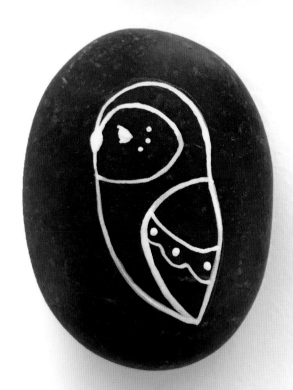

Step 3 Using your smallest brush, take time to paint your owl's eye. Every owl is unique; enjoy creating different expressions with your owl's eye.

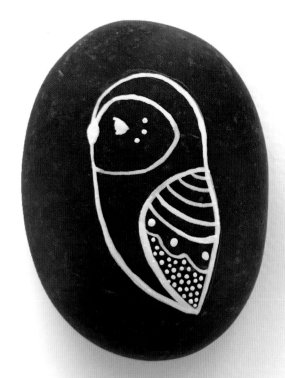

Step 4 Begin adding fine details to your owl's wing.

Step 5 Fill in your owl's body with paint, avoiding the face and wing.

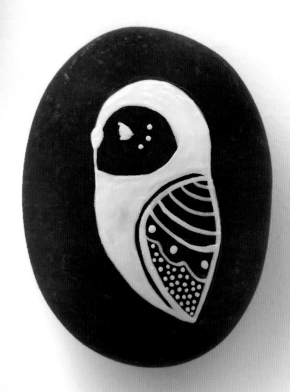

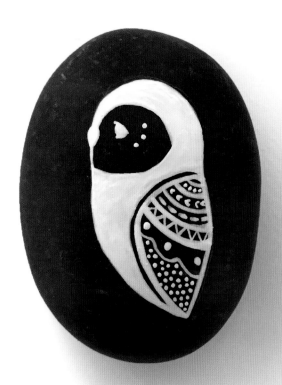

Step 6 Continue adding the final details to your owl's wing. Create your own shapes and patterns and customize them to match your owl's personality.

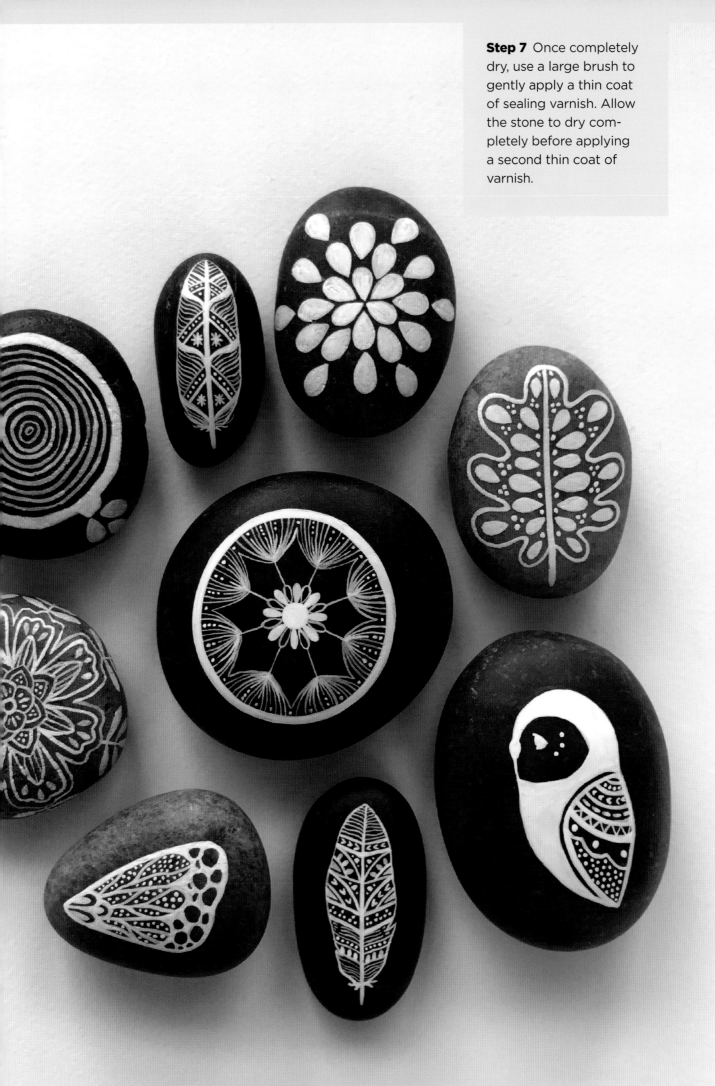

Step 7 Once completely dry, use a large brush to gently apply a thin coat of sealing varnish. Allow the stone to dry completely before applying a second thin coat of varnish.

Nature PATTERN

with MARISA REDONDO

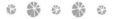

Step 1 Select a stone with an unusual shape and a smooth painting surface. After cleaning and drying the stone, apply a single thin coat of varnish. Using a small round brush, begin by painting a line across the top of your rock. This line will help keep your pattern straight while working.

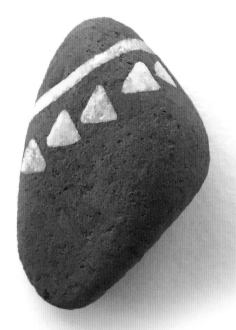

Step 2 Next paint a row of small triangles. It's easiest to keep them symmetrical by starting with a "V" shape and then carefully filling with paint.

Step 3 With a steady hand, paint two lines along the other side of the triangles.

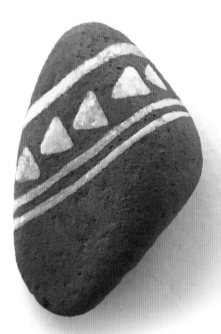

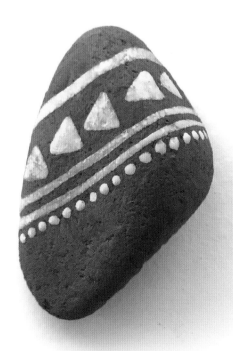

Step 4 Continue the pattern with a row of small dots. Using a small round brush, dip the tip of your brush in the paint for each dot.

Step 5 Paint one last line underneath the row of small dots.

Step 6 Add small dashes along the bottom of the line, as shown.

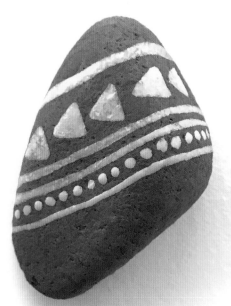

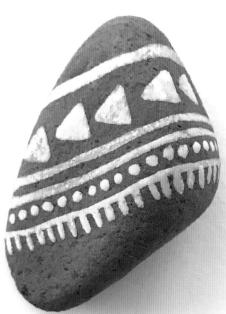

Step 7 To finish the design, add small dashes above the top line, to mirror the pattern along the bottom.

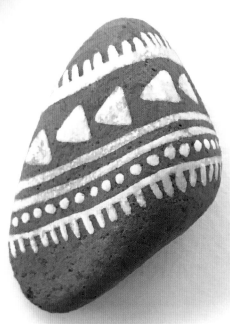

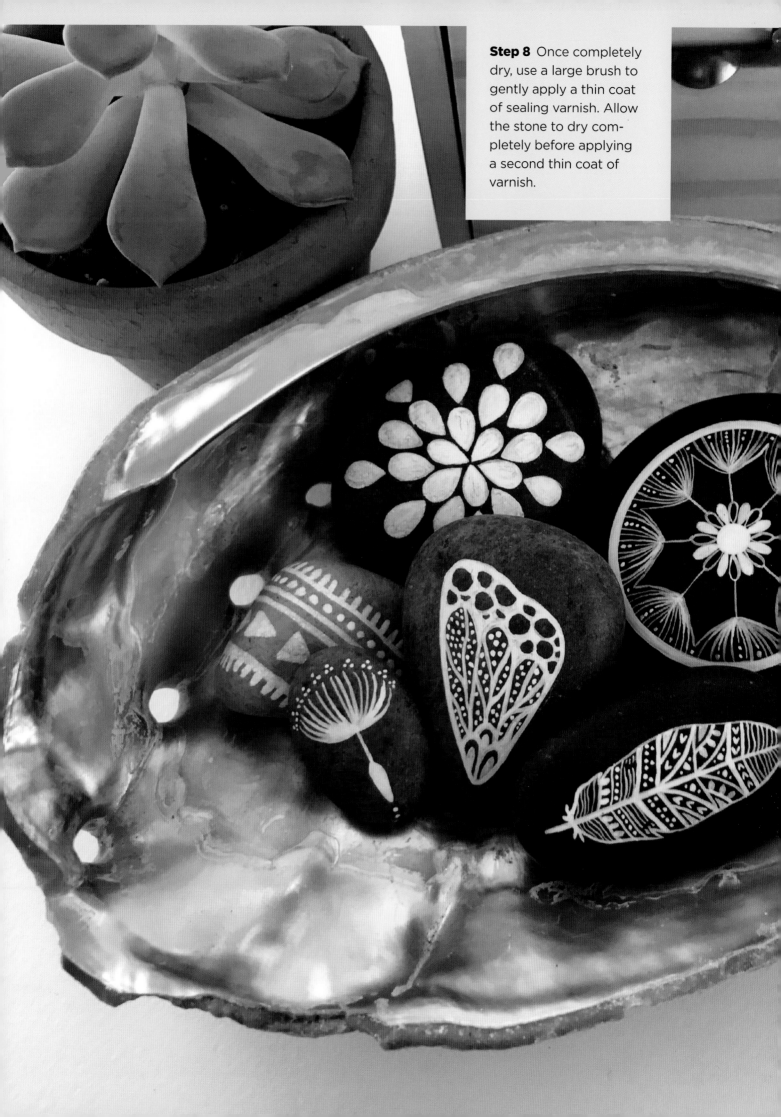

Step 8 Once completely dry, use a large brush to gently apply a thin coat of sealing varnish. Allow the stone to dry completely before applying a second thin coat of varnish.

About the ARTISTS

Artist **F. Sehnaz Bac** is celebrated for her radiantly colorful and charming painted stones, which she sells on Etsy as *I Sassi dell'Adriatico* (Adriatic Stones). Born in Istanbul, Turkey, she studied Archaeology and mastered in restoration and conservation. She has been drawing for as long as she can remember. Her curiosity and imagination inspires her to create very detailed, fine-line drawings and stylized designs inspired from nature. She works with bright and bold colors in a variety of media, including watercolor, acrylic, ink, and marker pens. She currently lives in Alba Adriatica, Italy, a small town on the Adriatic Sea.

Artist and illustrator **Marisa Redondo** works primarily with watercolors and oils. Most of her work is nature inspired. Art has always been her greatest love. Growing up in the heart of San Diego, drawing was how she found a calm balance in the busy city. Currently based in Northern California, Marisa is fascinated by nature's creations and the little pieces of life that often go unnoticed, from the fine lines of feathers to the spores of a dandelion. Through watercolor she explores the organic patterns and intricate details impressed on everything from the earth. Her paintings are a mix of the modern city she came from and the natural land where she now lives. Learn more at www.riverlunaart.com.

Talented artist **Margaret Vance** paints beautifully vibrant and colorful rock art full of intricate detail and pattern. As in nature, no two painted stones are alike. A simple stone washed downriver becomes a natural and surprisingly fitting canvas. Each stone's size, shape, color, surface texture, and individuality influence the design to create a singular mix of art and nature. Learn more at www.etherealandearth.com.